Go Harlem Go Harlem Go Harlem Start right now!

To My Sister
"Genay"

Peace and Blessings

Gerelise Joel Holloway

2017

GATHER OUT OF STAR-DUST

A Harlem Renaissance Album

Melissa Barton

Published by Beinecke Rare Book & Manuscript Library
Distributed by Yale University Press, New Haven and London

Contents

MUSTER 1-9

ENTERTAIN 10-21

GET TOGETHER 22-34

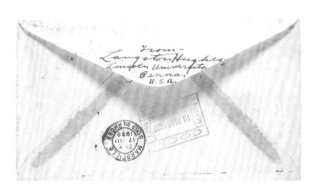

GARNER 35-40

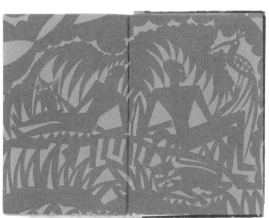

COLLECT 41-50

Gather Out of Star-Dust:
The Harlem Renaissance and The Beinecke Library

Melissa Barton

In an era that made Bessie Smith and Bill "Bojangles" Robinson household names, taught the world to Charleston, and introduced Langston Hughes, America's favorite poet, African American cultural and intellectual endeavor surged into the American mainstream. Hughes himself described the period most aptly, just after it ended, as the time "when the Negro was in vogue."[1] Called a "movement" or "renaissance" by many of its own participants, and now most commonly remembered as the Harlem Renaissance, the period from about 1917 to about 1939 saw unprecedented achievements in African American publication, performance, and visual arts. In the near century since that time, this period has captured the American popular imagination with its style, music, and dance, and elicited hundreds of scholarly monographs and articles, multiple encyclopedias, dictionaries, and guides, dozens of reprints, exhibitions, and revivals. It has been revisited, reexamined, revaluated, and revised, to use words from the titles of four collections of criticism and history. It has inspired performances from George Wolfe's *Shuffle Along* on Broadway to Terence Winter's *Boardwalk Empire* on HBO.

Gather Out of Star-Dust, a companion volume to the 2017 exhibition at Beinecke Rare Book & Manuscript Library, seeks to return us to the documents, photographs, artworks, and objects that have generated this tremendous response of scholarship, inquiry, and homage. In addition to its revolutions in creative expression, the Harlem Renaissance produced a revolution in the act of saving and collecting the black past. In 1926, the year after Alain Locke's landmark anthology *The New Negro* was published, Afro-Puerto-Rican bibliophile Arthur Schomburg sold his massive collection of African American books, periodicals, and pamphlets to the New York Public Library. Schomburg's library became the nucleus of the Schomburg Center, today one of the world's foremost research institutions for the study of African Americans and the African diaspora. Other library collections founded around the same time include the Moorland-Spingarn Research Center at Howard University, formed by two major donations in 1914 and 1946, and the James Weldon Johnson Memorial Collection of Negro Arts and Letters, founded in 1941 at Yale University.[2]

When it celebrated its seventy-fifth anniversary in 2016, the James Weldon Johnson Memorial Collection held over 13,000 volumes, 3,000 pieces of sheet music, countless pages of manuscripts, correspondence, photographs, and ephemera, and 11,000 digital images, and was one of the most consulted collections in the Yale Library. The collection spans the history of African American cultural production, from the first published volumes of Phillis Wheatley (1773) to the paper and digital records of groundbreaking twenty-first century poetry community

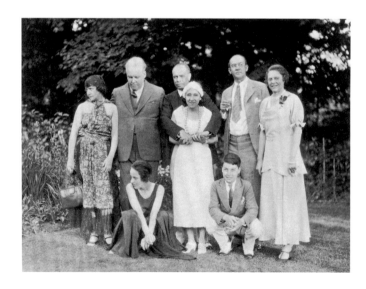

Birthday celebration for Carl Van Vechten, James Weldon Johnson, and Alfred Knopf, Jr., June 17, 1931. From left, standing: Ettie Stettheimer, Carl Van Vechten, James Weldon Johnson with his arms around Fania Marinoff, Witter Bynner, Grace Nail Johnson. Crouching: Blanche Knopf and Alfred A. Knopf, Jr. Photograph by Alfred A. Knopf.

Cave Canem. With its core strength in Harlem Renaissance materials, the collection stands as a memorial not only to Johnson, whose multivalent career reached its heights in that period, but also to the movement itself. A true renaissance man—poet, song writer, political activist, historian, educator—Johnson exemplified in his life the breadth and the variety of the collection that bears his name. Collection founder Carl Van Vechten, novelist, critic, and photographer, was a close friend of Johnson's: they shared a birthday and often celebrated it together. In soliciting donations to the collection, Van Vechten cited Johnson's commitment to "cultural development as a means of advancing the dignity of the American Negro in national life."[3] Johnson himself had written of the power of cultural development in the aggregate in his preface to *The Book of American Negro Poetry* (1922). There he argued that the culture of a group could prove that group's worth to the world. The idea that culture could make a powerful political argument became a widespread belief among the leaders of the Harlem Renaissance. Though many today may see that view as naïve, the James Weldon Johnson Collection's presence and profile in the Beinecke Library attest to the achievement that Johnson and others had in mind.

The spirit of collection, of collaboration, of combining forces, was very much alive throughout the Renaissance in such projects as the 1917 Negro Silent Protest Parade, *The New Negro*, and the 1926 journal *Fire!!*, as well as the theatrical productions, salons, friendships, partnerships, and sponsorships that marked this period. When the James Weldon Johnson Collection formally opened on a cold but sunny January day in 1950, Charles S. Johnson, one of the leaders of the literary movement, described how the collection would unite "in respect and friendship" two men: James Weldon Johnson, the revered leader and man of letters, and Carl Van Vechten, the dilettante who had nevertheless befriended and patronized numerous African American artists.[4] The collection was more than Van Vechten's alone: more than 150 people, listed in the program for the opening, had already contributed materials by 1950. Donors included Paul and Eslanda Robeson, W. E. B. Du Bois, Ralph Ellison, Langston Hughes, Zora Neale Hurston, and Countée Cullen. As the citation from the President and Fellows of Yale University read, the collection would house "materials through which the important contribution of the American Negro to the art and literature of his time is revealed."

The materials in the James Weldon Johnson Memorial Collection have been the basis for major works of history, biography, and criticism. They have inspired novelists and poets, visual and performing artists. While the President and Fellows of Yale University recognized

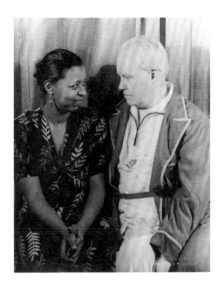

Ethel Waters and Carl Van Vechten in 1939. Photograph by Carl Van Vechten.

the "important contribution" of African Americans to art and literature, many Harlem Renaissance thinkers, including James Weldon Johnson himself, argued that African Americans were making more than just contributions—they were making American culture as we know it today, with reverberations that would be felt from Broadway to Motown to Hollywood, from the pages of the nation's foremost cultural gatekeepers to the ivory tower. Productions like 1921's *Shuffle Along* revolutionized American musical comedies. The poetry of Langston Hughes and Sterling Brown infused traditional verse with African American vernacular rhythms. The music and performance cultures of Harlem, Memphis's Beale Street, Chicago's South Side, and other similar neighborhoods brought blues and jazz music to national attention. Novels featuring African American lives told realistically, without stereotype or caricature, flew from the shelves.

This tremendous output was made possible by equally significant demographic and intellectual changes taking place throughout the United States. By 1925, more than 1.5 million African Americans (more than ten percent of the total national population of African Americans) had left the rural South for northern and western cities. Many of their destinations would become known for their African American cultural institutions, like New York, Chicago, and Los Angeles, but also Washington, D.C., home of the great Howard University, and Cleveland, home of the Karamu Theatre. By the end of World War II, the number of migrants would reach an estimated six million. At the same time, in academic institutions like Harvard, Columbia, and The University of Chicago, new approaches to American philosophy, anthropology, and sociology were making these institutions and other tastemakers more interested in and open to the multicultural character of the United States, especially African American culture.

This volume is organized into five thematic sections, each a mode of "Gather": Muster, Entertain, Get Together, Garner, and Collect. Its fifty entries showcase materials from the James Weldon Johnson Memorial Collection of African American Arts and Letters. The work of this period has long raised some of the best questions about culture and its purpose: What is beautiful? What is good? What is it for? Who owns it? Can art change the lives of those who are poor and suffering? Many scholars have criticized the New Negro literary movement as a "failure" for not ending racial discrimination by the pen and the brush, or for presenting a unified front while silencing gay, West Indian, and leftist voices. Sterling Brown, reflecting back on the movement in 1955, objected to the association of the movement with Harlem, calling it "the show-window, the cashier's till, but no more Negro America than New York is America."[5] *Gather Out of Star-Dust* brings these questions and criticisms back to the materials, to show the complexity of the era through the juxtaposition of its artifacts. We can ask and remember, but also enjoy.

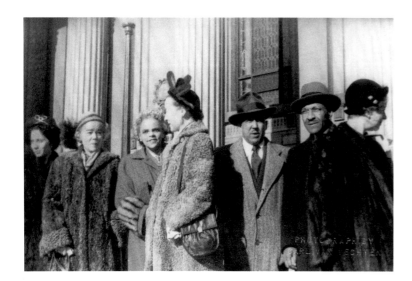

Guests outside Yale Commons at the opening of the James Weldon Johnson Memorial Collection of Negro Arts and Letters, January 7, 1950. From left: Ellen Tarry, Dorothy Peterson, Marie Johnson, Margaret Babb, Langston Hughes, Charles S. Johnson, Helen Channing Pollock. Photograph by Carl Van Vechten.

YALE UNIVERSITY

Exercises marking the opening of the

James Weldon Johnson
Memorial Collection of
Negro Arts and Letters

Founded by Carl Van Vechten

SPRAGUE MEMORIAL HALL

7 January 1950

Program from the Opening of the
James Weldon Johnson Memorial
Collection of Negro Arts and Letters.
James Weldon Johnson Memorial
Collection, Beinecke Rare Book &
Manuscript Library.

1
Langston Hughes, *The Big Sea* (New York: Hill and Wang, 1993 [1940]), 223.

2
The collection is now commonly referred to as The James Weldon Johnson Memorial Collection of African American Arts and Letters.

3
Carl Van Vechten, "The Proposed James Weldon Johnson Memorial," Carl Van Vechten Papers, Yale Collection of American Literature/James Weldon Johnson Memorial Collection, Beinecke Rare Book & Manuscript Library.

4
Charles S. Johnson, "Literature and the Practice of Living," *Exercises Marking the Opening of the James Weldon Johnson Memorial Collection of Negro Arts and Letters founded by Carl Van Vechten*, January 7, 1950. James Weldon Johnson Memorial Collection, Beinecke Rare Book & Manuscript Library.

5
Sterling Brown, "The New Negro in Literature," *A Son's Return: Selected Essays of Sterling A. Brown*, ed. Mark A. Sanders (Boston: Northeastern University Press, 1996), 185.

Lift your heavy-lidded eyes, Ethiopia! awake!

Claude McKay, "Exhortation: Summer, 1919"

The literary and artistic movement in Harlem arose amidst a backdrop of growing political mobilization on the part of African Americans. The National Association for the Advancement of Colored People had been founded by an interracial coalition in 1909, on the 100th birthday of Abraham Lincoln, and the young N.A.A.C.P. established a program of campaigns against disfranchisement, school segregation, lynching and mob violence, and public discrimination on the basis of color.

In July 1917, responding to a brutal episode of mass racial violence in the city of East St. Louis, in which between fifty and two hundred African Americans were murdered and six thousand were left homeless by arson attacks, the N.A.A.C.P. and church and community leaders in New York City organized one of the first major mass demonstrations by African Americans: the Negro Silent Protest Parade. The brain child of **James Weldon Johnson**, an estimated 10,000 African Americans marched down Fifth Avenue from 57th Street to Madison Square, silently carrying banners condemning racial violence and racial discrimination. They indicted the United States and President Woodrow Wilson, who had just pledged to make the world safe for democracy. Throughout the march, the only sound came from the drums leading the procession. Behind the drummers marched a small band of N.A.A.C.P. officers and other organizers, including **W. E. B. Du Bois** and Johnson, who had joined the N.A.A.C.P. as a field secretary just eight months previously. Framed as leading the procession, there followed a group of children dressed in white, followed by women dressed in white, emphasizing the vulnerability of the victims in East St. Louis and throughout a country plagued by racial violence. Finally, men in dark suits brought up the rear, with banners expressing their outrage at racial injustice.

Racial tensions had reached alarming levels throughout the United States. The mass migration of African Americans from the rural south to northern urban centers—what would become known as the Great Migration—was well underway, and the ensuing tensions were exacerbated by competition for housing and jobs. The white supremacist order had mounted a fierce backlash. A flyer distributed by the N.A.A.C.P. in advance of the event enumerated the many reasons to participate with the refrain "We march." These included, "We march because the growing consciousness and solidarity of race coupled with sorrow and discrimination have made us one."[6] As the flyer suggests, organizations like the N.A.A.C.P. and African American churches met the growing racial violence with a consolidation of black political power.

The events in East St. Louis provided a preview for the terrible summer of 1919, when violence broke out in cities throughout the country including Chicago, Washington, D.C., Omaha, Nebraska, and Knoxville, Tennessee. James Weldon Johnson gave the season of horror its name: "Red Summer." But, in spite of that reversal, the Silent Protest Parade had established the organization of mass protest as possible. As Johnson wrote in his autobiography *Along this Way*: "The streets of New York have witnessed many strange sights, but, I judge, never one stranger than this; certainly, never one more impressive."[7]

1

Photographs of the Negro Silent Protest Parade 1917

James Weldon Johnson Memorial Collection

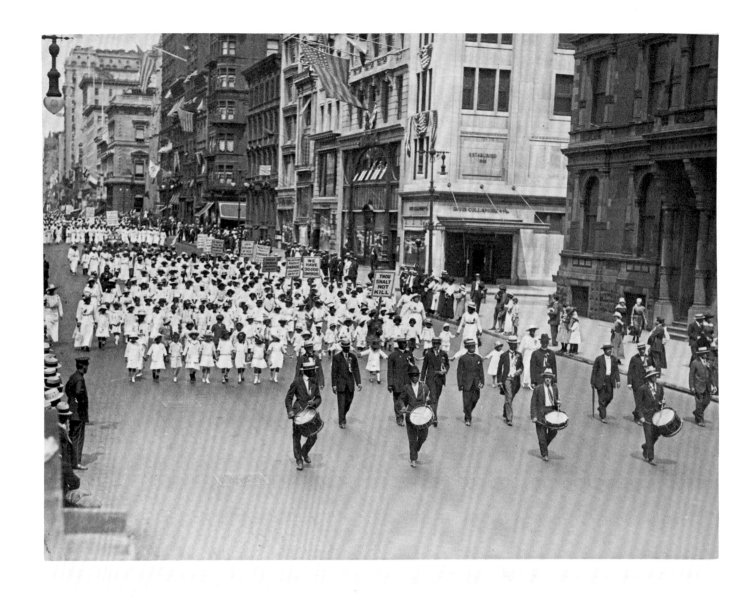

In his column in the *New York Age* on May 20, 1922, **James Weldon Johnson** announced with great fanfare that a "real poet" had arrived, "like a new and flaming star on the horizon." That poet was the Jamaican **Claude McKay**, his slim volume *Harlem Shadows* published that month by Harcourt, Brace and Company. In more than fifty short lyrics, McKay roared with a ferocity not yet expressed in African American poetry. He condemned his adoptive home country in "America": "Although she feeds me bread of bitterness […] I love this cultured hell that tests my youth!" He wrote with unflinching rage of poverty, lynching, and the devastation of 1919's "Red Summer," as in his most famous poem, "If We Must Die." In "Exhortation: Summer 1919," he called on his fellows of African descent, "lift your heavy-lidded eyes, Ethiopia! awake!"

Counterintuitively, at the very moment when *vers libre* had begun to rule modern poetry, McKay couched his passion in the sonnets and formal rhyming verse of an earlier era. In an author's note, he offered a history of his linguistic development, which he described as combining the African-influenced folk traditions of black Jamaicans and the "England's English" he used in school. "I have adhered to such of the older traditions as I find adequate for my most lawless and revolutionary passions and moods." The result was a poetry of passions and moods straining at elegant containers. Though perhaps not McKay's chief intent, Johnson declared, "What he has achieved in this little volume sheds honor upon the whole race."

The 33-year-old McKay had emigrated from Jamaica to the United States ten years earlier to study agriculture at the Tuskegee Institute, but he quickly dropped out, adopting an itinerant life of menial labor and eventually landing in New York. There he wrote articles and published poetry in **Max Eastman's** radical socialist journal *The Liberator* and **A. Philip Randolph's** black socialist *Messenger*. Eastman wrote an introduction for *Harlem Shadows*, in which he noted the deep universality of McKay's poems, beyond their representation of a single race and its experience. Eastman's emphasis on McKay's race as a series of life experiences and circumstances, rather than a biological fact with attendant natural features, reflected a new view of race that had begun to take hold in the early decades of the twentieth century.[8] In addition, Eastman suggested that the suffering of African American experience provided fertile material for poetry, an argument to be found among many thinkers of this time.

Soon after the publication of *Harlem Shadows,* McKay traveled to Russia to observe the results of the Bolshevik Revolution, of which he had written admiringly.[9] He remained abroad, living in Berlin, Paris, the south of France, Barcelona, and Tangiers, only returning to the United States in 1934. He observed and participated in the literary movement that dawned with his first book entirely from afar, but his writing and his friendship with several key figures of the movement, most notably **Langston Hughes**, meant that his presence was felt in Harlem. African American literary critic **Joel Augustus Rogers** dubbed "If We Must Die" the "Negro Marseillaise," and the poem has since become one of the most popular, and most frequently reprinted, poems by an African American.[10]

2

Claude McKay, *Harlem Shadows*
First Edition, Harcourt, Brace and Company
1922

James Weldon Johnson Memorial Collection

HARLEM SHADOWS

BY
CLAUDE McKAY

WITH AN INTRODUCTION BY
MAX EASTMAN

"These poems have a special interest for all the races of man because they are sung by a pure blooded Negro. Here for the first time we find our literature vividly enriched by a voice from this most alien race among us. And it should be illuminating to observe that while these poems are characteristic of that race as we most admire it—they are gentle—simple, candid, brave and friendly, quick of laughter and of tears—yet they are still more characteristic of what is deep and universal in mankind."—From the Introduction.

Though its activities took place, at best, alongside the literary and cultural movement of the Harlem Renaissance, no narrative of the Harlem Renaissance could be complete without a discussion of the Universal Negro Improvement Association (U.N.I.A.), founded by the Jamaican **Marcus Garvey**. Garvey's advocacy of black nationalism and the return of African Americans and West Indians to Africa to form a kingdom of the darker peoples of the world captured the imaginations of tens of thousands of African Americans in Harlem and throughout the United States. The New York branch of the U.N.I.A. alone had between 35 and 40,000 members, nearly half the size of the entire national readership of the N.A.A.C.P.'s Crisis at its height. With the motto "One God, One Aim, One Destiny" and the slogan "Africa for the Africans," this set of philosophies would come to be known by the name of its leader as Garveyism.

Born in Jamaica in 1887, Marcus Mosiah Garvey arrived in the United States in 1916 after a brief stint in London, during which he frequently occupied Speaker's Corner in Hyde Park. Garvey had founded the U.N.I.A. in Jamaica in 1914, and by 1918 he had incorporated the organization and headquartered himself in offices on 135th Street, in the heart of Harlem. Charismatic, visionary, and a gifted orator, Garvey amassed followers quickly. His message of self-reliance and the celebration of African-descended people resonated with those suffering from racial injustice and persecution. In 1919, Garvey founded the Black Star Line Steamship Corporation, which advertised itself as preparing to ferry goods and shareholders back to the shores of Africa (though none of its ill-fated ships ever made it that far).

In 1920, Garvey convened an International Convention of the Negro Peoples of the World at Madison Square Garden, attended by 25,000. The convention was opened by a parade ten miles long, with Garvey riding in an open-topped car wearing military regalia.

This 1922 almanac celebrates the achievements of the Garvey movement and of African-descended peoples as a whole, with inspiring extracts from a wide variety of writers, including the enslaved eighteenth-century American poet Phillis Wheatley. Other pages list the Negro population in various parts of the world, the presidents of Liberia, and the officers of the U.N.I.A. One especially striking page juxtaposes the number of lynchings in the preceding five years with the enrollment of Tuskegee Institute in the same period. Though Garvey would attract fierce criticism from all sides, especially **A. Philip Randolph** at The Messenger and **W. E. B. Du Bois** at The Crisis, the almanac declares the U.N.I.A. and the N.A.A.C.P. to be kindred organizations, only with differences in scope.

Under constant suspicion and surveillance by J. Edgar Hoover's nascent F.B.I., Garvey was eventually arrested and charged with mail fraud in connection with the activities of the Black Star Line. He served three years before his five-year sentence was commuted on condition of his deportation back to Jamaica.

3

Almanac of the Universal Negro Improvement Association 1922

James Weldon Johnson Memorial Collection

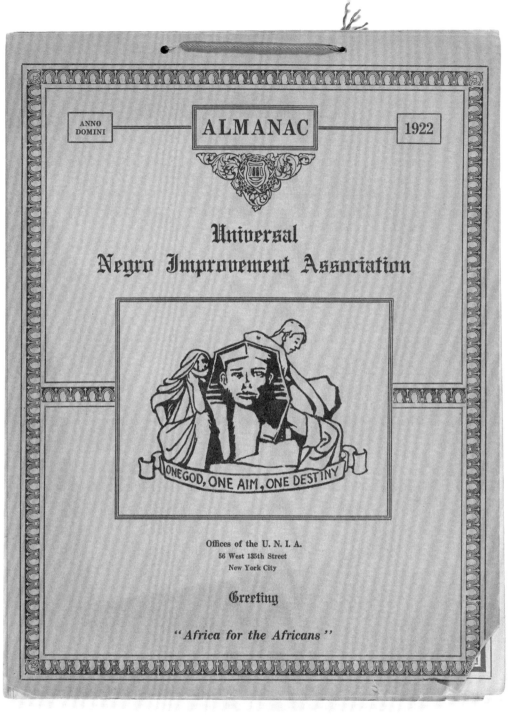

| ANNO DOMINI | ALMANAC | 1922 |

Universal Negro Improvement Association

ONE GOD, ONE AIM, ONE DESTINY

Offices of the U. N. I. A.
56 West 135th Street
New York City

Greeting

"Africa for the Africans"

In compiling the first anthology of African American writing to be published by a major New York publisher, **James Weldon Johnson** recognized that a notable and growing critical mass of African American poets had begun to take shape. Between his long-recognized late friend **Paul Laurence Dunbar** and relative newcomers like **Claude McKay** and **Anne Spencer** lay a body of work significant enough to be called "a literature." Johnson declared as much in a preface to the edition that has come to be considered a founding document of the Harlem Renaissance: "A people may become great through many means, but there is only one measure by which its greatness is recognized and acknowledged. The final measure of the greatness of all peoples is the amount and standard of the literature and art they have produced. The world does not know that a people is great until that people produces great literature and art. No people that has produced great literature and art has ever been looked upon by the world as distinctly inferior."

The program Johnson describes here was inaugurated in some respects by **W. E. B. Du Bois** at the turn of the century, when the elder statesman of African American intellectuals argued that the greatest talents of the race—the so-called "talented tenth"—would both lead the race to equality and demonstrate to the ruling classes that all its members were deserving of equal treatment. Johnson's focus on literature and the arts, which would be taken up in tandem by **Charles S. Johnson**, **Alain Locke**, and Du Bois's colleague and right hand **Jessie Redmon Fauset**, modeled itself on the suggestion from many quarters that African Americans could emulate the Irish. The Irish Literary Revival was noted for its celebration of the ordinary Irish "folk," particularly in the plays of John Millington Synge in the first decade of the twentieth century. The literary movement was also recognized by African Americans as a liberation movement: one that had inspired, and been inspired by, the political action and organizing of Irish nationalism. The cultivation of vernacular themes and race pride became a key facet, and occasionally a point of contention, in the Negro literary movement.

Johnson's anthology arrived at what would, in retrospect, be clearly seen as the dawn of that movement. Eight years later, after the movement had passed its zenith, Johnson issued a revised edition of his anthology, adding most of the poets we identify with the Harlem Renaissance today, such as **Langston Hughes**, **Countée Cullen**, **Gwendolyn Bennett**, **Sterling Brown**, and **Helene Johnson**. James Weldon Johnson, meanwhile, was recognized as an important gatekeeper for the legitimacy of African American culture. His poetry anthologies and his *Book of American Negro Spirituals* (1925) brought mainstream recognition to African American artists, not least the "Black and Unknown Bards" who composed the spirituals.

4

James Weldon Johnson, *The Book of American Negro Poetry*
First Edition, Harcourt, Brace and Company
1922

James Weldon Johnson Memorial Collection

The Book
of
American
Negro
Poetry

Chosen and Edited
With an Essay on
The Negro's Creative
Genius By
JAMES WELDON
JOHNSON

Very few people know how much good poetry, not only in dialect but also in straight English, the Negro race has contributed to American Literature. This book is the first to give an idea of the Negro poets of America from Paul Laurence Dunbar to the writers of to-day. Mr. Johnson is himself a poet of distinction, and his introductory essay is both suggestive and stimulating.

Looking back on the Harlem Renaissance in 1963, **Arna Bontemps** recalled the appearance of **Jean Toomer** with his 1923 book *Cane* as a "sunburst."[11] A volume of experimental short fiction and poetry that defied description when it was published, portions of *Cane* had been seen in the modernist little magazines *Broom, Little Review,* and *Modern Review* as well as **Max Eastman's** socialist *Liberator* and the N.A.A.C.P.'s *Crisis*. This eclectic mixture of outlets mirrored Toomer's conception of his own internal idiosyncrasy. As he wrote to the editors of *The Liberator* in 1922, his own personal blend of seven races had made his "position in America a curious one. I have lived equally amid the two race groups. Now white, now colored. From my own point of view I am naturally and inevitably an American. I have strived for a spiritual fusion analogous to the fact of racial intermingling."[12] Throughout his life, Toomer maintained that he was neither white nor black, but simply "American." At the same time, he noted that he had drawn his inspiration for *Cane* from a visit to Georgia in the fall of 1921: "I heard folk-songs come from the lips of Negro peasants. I saw the rich dusk beauty that I had heard many false accents about, and of which till then, I was somewhat skeptical."

Illustrating the lives of African Americans in rural Georgia and urban Washington, D.C. in alternating sections, Toomer was lauded for portraying Southern African American life realistically and in counterdistinction to the caricatures of Octavius Roy Cohen and Joel Chandler Harris. Adding a haze of aestheticism to its subjects, Toomer's writing was also viewed as distinctly "modern," deploying a level of what reviewers at the time called "mysticism." He also demonstrated the contrast between the ever-growing northern urban black population and its southern "folk" roots, particularly in the volume's culminating novelette, "Kabnis," the first of many Harlem Renaissance tales of educated African Americans journeying back to the South.

Cane received positive reviews but sold only 500 copies. The more the African American intelligentsia embraced the volume, the more Toomer tried to distance himself from it. He felt betrayed by his friend **Waldo Frank**, the eminent modernist writer, whose introduction to *Cane* had identified Toomer as a "Negro writer." Toomer refused his publisher's efforts to use a racial identification he disavowed to market his book. When **Winold Reiss** included a portrait of him in *The New Negro* (along with excerpts from *Cane* selected by **Alain Locke**—without Toomer's permission), Toomer was appalled.[13] He never conceived of himself as an African American.

Toomer's notebooks are as notable for their abstractions as Cane is for its concreteness. "A personality, an intelligence, a vision, a style, consciously *penetrating* adequate material, produce organic form. These elements, consciously *controlling* adequate material, achieve artificial pattern. In a perfect artist, these two processes would be synchronal. A coincidence of the organic and the artificial form—this is perfect art." It is perhaps not surprising that a thinker so conceptually oriented would become attracted to the teachings of **Georges Ivanovich Gurdjieff**, the Russian philosopher and mystic who stressed the pursuit of higher consciousness. Toomer's interest in Gurdjieff led him away from writing fiction and poetry. In 1924, less than a year after the publication of *Cane* and just as the Harlem literary movement was gaining momentum, Toomer moved to France to study at Gurdjieff's institute.

5

**Jean Toomer, *Cane*
First Edition, Boni & Liveright
1923**

James Weldon Johnson Memorial Collection

**Jean Toomer, Journal
1920**

Jean Toomer Papers

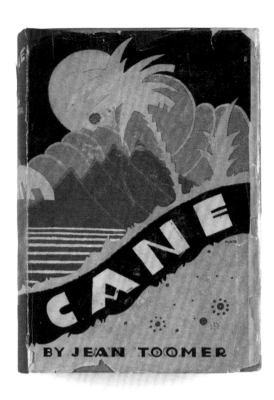

modern reality can only (or perhaps, even better) be
conveyed in terms of the contemporary setting.
Beneath, and not without, the complexities of thought
and human emotion must be revealed the modern
essence, which, of course, is similar to the essence
of all ~~things~~ times. This involves no sacrifice.
It does impose an immense burden upon the artist.
He must be, while remaining the artist, as manifold
and as diverse as his age. It imposes, the power
of comprehension, of selection, of organization on a
scale hitherto unknown upon the direct capacity,
for aesthetic experience. The purity of a piece of
contemporary literature will depend ~~out~~ not only
upon its simplification but also upon its fineness
and balance.

 — the facile, pat criticisms, given by men in
various walks of life upon the achievements of another.

 Genius, like the sturdiest prize potato will rot
if kept too long under ground.

 Method — To make two sensitive people cognizant
of the shy gestures and expressions, one of the other, inhabits
a third person, who, though he sees, is too forthright
to keep what he sees to himself.

People return to homes. They have been away on trips,
visitors, honeymoons, perhaps. Once back, it is as though
they had never gone away, as if they had been in the
homes thousands of years. They bring no fresh breath
of the sea side with them, no mobile freshness of traveled
rivers.

When I include color *I do so* not because it is local,
but because I love it.

 — a dainty life of tit bits and tassels.

South — the white of white becomes unreal. Whiteness
becomes a shade, vaguely oppressive. A dominant shade
sheathed with moist. A cloud ~~which~~ is near to me
because I walk on mountains. When I look up
from the darkness of the valley, it is so.

Education's real function is to render the memory serviceable.
Whatever it may be in a young girl's dreams, whatever it might
be in an ideal society, love plays but a small part in actual
life, and its portion is still smaller in the life of an artist.

With its title taken from abolitionist James Russell Lowell's 1845 poem "The Present Crisis," the journal of the National Association for the Advancement of Colored People signaled the urgency of the national racial climate even as the Civil War was fading into memory. The N.A.A.C.P. had linked its founding to the rhetoric of the war from its inception, founded in 1909 on the 100th birthday of Abraham Lincoln. But its organ, *The Crisis*, spoke with the voice of its editor, **W. E. B. Du Bois**, whose monthly editorials, news articles, commentaries, and book reviews addressed every available topic of the day, from electoral politics to the coverage of small town newspapers, from lynchings to the arts. Du Bois's seminal work *The Souls of Black Folk* had been published in 1903. By the late teens, he had graduated to the role of elder statesman, and he would be treated as such in the early years of the New Negro movement. Du Bois was an idol to many younger writers in the movement: when **Langston Hughes's** debut poem, "The Negro Speaks of Rivers," appeared in the pages of *The Crisis* in 1921, he dedicated it to Du Bois.

Hughes had been "discovered" by **Jessie Redmon Fauset**, *Crisis* literary editor and Du Bois's sometime right hand. Though known and best remembered for her commitment to gentility and respectability in her own fiction, Fauset ushered a new generation of poets and writers onto the pages of *The Crisis* after she was appointed in 1919, including Hughes, **Countée Cullen**, **Gwendolyn Bennett**, **Nella Larsen**, and **Claude McKay**. For this, Hughes credited her in his autobiography *The Big Sea* as a "midwife" of the Harlem Renaissance, along with **Alain Locke** and **Charles S. Johnson**.[14]

At the height of its influence in 1919, circulation of *The Crisis* neared 100,000 per month. Increased migration from the rural South to northern cities and the participation of African Americans in the war effort had stoked optimism for tangible progress in the fight for racial equality. In his May 1, 1919 editorial, Du Bois concluded a discussion of the end of World War I resolving: "*We return. We return from fighting. We return fighting.*"

By the mid-1920s, the popularity of *The Crisis* had begun to decline, overtaken in part by its rival, *Opportunity*. In 1926, Fauset resigned her post as literary editor for reasons that remain unclear to this day. At the same time, Du Bois had become mired in his opposition to **Carl Van Vechten's** controversial novel *Nigger Heaven*, to be followed two years later by a public debate between Du Bois and Claude McKay over the appropriateness of the subject of McKay's novel *Home to Harlem*. *The Crisis* was being edited out of relevance. Though it continues to be published today, it has lost a significant amount of influence, beginning when Du Bois resigned as editor in 1933.

6

The Crisis: A Record of the Darker Races
1910–

James Weldon Johnson Memorial Collection

Educational Institutions Continued on page 38

THE CRISIS

Vol. 18—No. 1 MAY, 1919 Whole No. 103

Opinion of W. E. B. Du Bois

MY MISSION

I WENT to Paris because today the destinies of mankind center there. Make no mistake as to this, my readers.

Podunk may easily persuade itself that only Podunk matters and that nothing is going on in New York. The South Sea Islander may live ignorant and careless of London. Some Americans may think that Europe does not count, and a few Negroes may argue vociferously that the Negro problem is a domestic matter, to be settled in Richmond and New Orleans.

But all these careless thinkers are wrong. The destinies of mankind for a hundred years to come are being settled today in a small room of the *Hotel Crillon* by four unobtrusive gentlemen who glance out speculatively now and then to Cleopatra's Needle on the Place de la Concorde.

You need not believe this if you do not want to. They do not care what you believe. They have the POWER. They are settling the world's problems and you can believe what you choose as long as they control the ARMIES and NAVIES, the world supply of CAPITAL and the PRESS.

Other folks of the world who think, believe and act;—THIRTY-TWO NATIONS, PEOPLES and RACES, have permanent headquarters in Paris. Not simply England, Italy and the Great Powers are there, but all the little nations; not simply little nations, but little groups who want to be nations, like the Letts and Finns, the Armenians and Jugo-Slavs, Irish and Ukrainians. Not only groups, but races have come—Jews, Indians, Arabs and All-Asia. Great churches, like the Greek Orthodox and the Roman Catholic, are watching on the ground. Great organizations, like the American Peace Society, the League to Enforce Peace, the American Federation of Labor, the Woman's Suffrage Association and a hundred others are represented in Paris today.

In fine, not a single great, serious movement or idea in Government, Politics, Philanthropy or Industry in the civilized world has omitted to send and keep in Paris its Eyes and Ears and Fingers! And yet some American Negroes actually asked WHY I went to help represent the Negro world in Africa and America and the Islands of the Sea.

But why did I not explain my reasons and mission before going? Because I am not a fool. Because I knew perfectly well that any movement to bring the attention of the world to the Negro problem at this crisis would be stopped the moment the Great Powers heard of it. When, therefore, I was suddenly informed of a chance to go to France as a newspaper correspondent, I did not talk —I went.

What did I do when I got there? First, there were certain things that I did NOT do. I did not hold an anti-lynching meeting on the Boulevard des Italiens. I would to God I

7

Helmed by **Charles S. Johnson**, perhaps the least widely known of the leaders of the Negro literary movement, *Opportunity* served as the organ of the National Urban League. In contrast to the N.A.A.C.P., the Urban League had been founded as an organization dedicated to Progressive Era notions of uplift, focusing on ameliorating conditions of poverty among urban African Americans, especially new migrants. In contrast, then, to the more politically active Du Bois and *The Crisis*, the title "Opportunity" reflected a difference in mission. Begun in 1923, *Opportunity*'s immediate predecessor was a bulletin of the Urban League containing reports of studies about housing, unemployment, and various social conditions of black life. Johnson, charged with the editorship from the outset, had earned his degree in sociology studying under **Robert Park** at The University of Chicago. But Johnson devised a way to package the drier sociological reports, which included writings by **E. Franklin Frazier** and **Kelly Miller**, in a publication that would draw a larger readership.

Johnson viewed political opportunities for African Americans as hopelessly proscribed: the military, elective office, labor unions, all were effectively closed to African American participation. The arts were the one arena in which African Americans could hope to make advancements toward racial equality. Like **James Weldon Johnson** (to whom he was unrelated), Johnson believed that the arts could act as a powerful argument. After the now-famous catalyzing Civic Club dinner in 1924 and the ensuing publications of the special Harlem number of *Survey Graphic* and *The New Negro*, Johnson announced annual literary prizes, funded after the first year by Harlem's racketeer-philanthropist **Casper Holstein**. Winners (awarded at more lavish dinners) included **Langston Hughes**, **Countée Cullen**, **Zora Neale Hurston**, **Sterling Brown**, and **Georgia Douglas Johnson**.

By 1926 Johnson had hired Cullen as his assistant editor. Cullen's column "The Dark Tower" commented on the aesthetics of the literary movement. Meanwhile, in August of that year, **Gwendolyn Bennett**, poet from Washington, D.C., graduate of Pratt Institute, and freshly returned from a year of study in Paris, began a column that Johnson described as "carrying informal literary intelligence." "The Ebony Flute," as it was called, treated the literary talents of Harlem as celebrities, relaying their travels, publications, and reports from the field. A typical note read, "Langston Hughes is going South this summer...I believe he has some sort of romantic idea about sailing down the Mississippi River—that ought to bring forth some new poems full of the chugging rhythm of the old steamboat."

Graphically more forward-thinking than the relatively staid *Crisis*, *Opportunity* featured cover art by Bennett, **Aaron Douglas** (whom Johnson had recruited to New York from a position teaching high school in Kansas City), **Charles Cullen** (who illustrated Cullen's books *Copper Sun* (1927) and *The Black Christ* (1929)), and **Richard Bruce Nugent**. Poetry by Hughes was often accompanied by artwork by Douglas: a special folio of broadsides was printed as a holiday fundraiser in 1926.

With as much as forty percent of its readership white, *Opportunity* reached its peak circulation in 1927 with 11,000 readers, a small fraction of *The Crisis*'s readership in its heyday. That same year, the journal unexpectedly lost its grant funding. A year later, Charles Johnson left his post to join the faculty at Fisk University in Nashville, and the magazine quickly declined.

7

Opportunity: A Journal of Negro Life 1923–1942

James Weldon Johnson Memorial Collection

OPPORTUNITY
A JOURNAL OF NEGRO LIFE

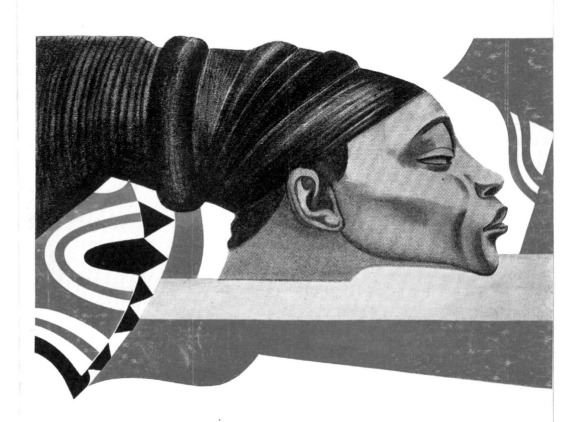

MAY, 1927

15c

The familiarity of the phrase "Harlem Renaissance" today often elides the myriad divisions among African American artists and thinkers of the time concerning the proper subject of art and its role. Should art reflect the race of the writer, or is the best art that which successfully masks the artist's race? Is it possible for art to be universal or free of propaganda? Should art portray common people, or the "best" people, as representing the group? Could African American dialect be incorporated into art, or was dialect hopelessly mired in the legacy of blackface minstrelsy?

These questions and others prompted a succession of manifestoes published in the pages of *The Crisis* and *Opportunity*, as well as publications like *The Nation* aimed at an integrated readership. In 1926, **Jessie Fauset** at *The Crisis* circulated a survey, responses to which would be published under the title "The Negro in Art: How Shall He Be Portrayed?" When **Langston Hughes** received his copy of the questionnaire, he began recording his response directly on the back of Fauset's letter.[15] The result would be published by *The Nation* as "The Negro Artist and the Racial Mountain," Hughes's hallmark essay on the relationship between African American artists and their art.

Hughes recounts a dialogue with a friend, most likely based on **Countée Cullen**, who told him "I want to be a poet—not a Negro poet." Hughes interpreted this stance as a desire to be white, writing that the "urge within the race toward whiteness" was the "mountain standing in the way of any true Negro art in America." Hughes went on to skewer the pretensions of the "smug Negro middle class," contrasting them with "the so-called common element." From this common element, Hughes argued, the best cultural productions of African America had arisen—the spirituals and jazz. He urged artists to resist "American standardizations" and to express the heretofore unrecognized talent and beauty of black people. In his cry, "I am a Negro—and beautiful!" Hughes anticipated the slogan "Black is beautiful" by several decades. Indeed, the essay would be taken up as a standard bearer by the Black Arts Movement in the 1970s.

Though Hughes's essay is often treated as the rallying cry for artists of the Renaissance, it should be borne in mind that he spoke against as many people as he spoke for in writing it. Indeed, it is often forgotten that the preceding issue of *The Nation* carried an "opposing viewpoint" by Harlem's resident curmudgeon **George S. Schuyler** entitled "The Negro-Art Hokum." Schuyler argued that perceived cultural differences between the races were in fact regional differences between northern and southern residents of the United States; he went on to suggest that anyone finding essential differences between the races belonged in the camp of notorious scientific racist Lothrop Stoddard or the Ku Klux Klan.

8

Langston Hughes, "The Negro Artist and the Racial Mountain" *The Nation*, volume 122, number 3181 (June 23, 1926)

Yale Collection of American Literature

be clear, as with the steadily narrowing limit of supportable population the reproductive obligation of sex lessens, its unabated emotional compulsions tend to assume the proportions of a terrible—if ecstatic—enslavement. Already this appears in the current saturation of our art and literature with aspects of the struggle to rid ourselves, by rationalization, of this most ancient type of befuddlement. It is suggested in the querulous resort of certain of our intelligentsia to Europe, where achievement is not yet cleared of the mingled odor of amorousness and alcohol with which for five thousand years it has been penetrated. Under competent social scrutiny the confused and increasingly unsatisfactory handling of what are called sex problems is shown more and more to be involved with artificially induced extra-biological states of sex attraction. Inevitably with the shrinkage of the reproductive obligation these extra-biologic states will be found to be of diminishing interest and effectiveness.

With our characteristically American sentimentality in respect to sex, it is natural that the instinctive urge to reduce the emotional obfuscations of amorousness to something like their biologic proportions would be indirect and more or less unacknowledged. The numerically popular success of the movement toward prohibition, though it draws a considerable quota of the experientially convinced, quite certainly draws other numbers motivated by the instinct to seek relief from urges that exceed their function, by destroying artificial excitements. And for at least five thousand years extra-biologic amorousness has been so identified with alcohol that our popular phraseology scarcely takes account of one without the other. It is not inevitable that such general and instinctive movements as this one for the riddance of alcohol should be altogether wise in their procedure or even widely intelligent. It is normal to all mass movement that the individual assent or resistance to any deep-seated urge should appear so variously motivated. There are no doubt numbers of the adherents of prohibition whose subconscious recompense is the satisfaction they take in the deprivations of other people; just as there are ardent protagonists who under the slogan of personal liberty are masking a love of drunkenness—alcoholic or amorous—for its own sake. Nor does it affect the essentials of the problem one way or another that much of the practical resistance to the Volstead Act is mere adolescent protest against regulatory discipline, the as yet unsocialized need of doing what we like because we like it.

The variety and incongruity of the reasons for and against are only further evidences of the power of deep-seated social urges to transcend all our logic and intelligence.

To any one who will take the pains to uncover the early phases of the prohibition movement, as revealed in the pamphlets, public pronouncements, and programs of that time, it will be plain that its biologic derivation was then much more nearly conscious than it is now. This also follows the law of the emergence of wars, the generative causes of which tend, as the reality of war approaches, to disappear under a cloud of incidental emotionalism. That Frances Willard herself was perfectly clear as to the complete implication of all our hopes of social betterment in the removal of the one great source of moral and intellectual befuddlement, I think there can be no doubt. In the effort to avoid or uproot whatever blurs the edge of reality—drink, or lust, or war, or moral enthusiasm—all of which are more or less interchangeable as individual motivation, it is natural that drink should be the first to be objectively attacked. It presents a visible measure of economic convenience as a hand-hold, and strategically undermines the others. With the elimination of alcohol amorousness loses much of its enticement, and it is quite possible that the waning popularity of war is partly owed to its diminished opportunity for indulging the confluent appetites for drink and lust. That the effort to eliminate the first three occasions of emotional obfuscation should be the occasion of an accession of the last, most insidious intoxication, is perhaps the worst thing that can be said of it. For any moral enthusiasm invariably gives rise to counter-enthusiasms of immorality, against which the first frequently arrests itself, sometimes to the degree of temporary defeat. As this appears to be the present state of the prohibition movement, falling over itself in a too rapid progress toward its goal, this would seem to be the moment for both sides to abate their mutual fury of attack in a mutual recognition of the nature of the urge in which the movement takes its rise. It might prove in the end as doubtful an advantage to escape too soon as to hug too long, and on mistaken premises, a traditional release and incitement. One feels certain that a completely rationalized society would waste no more time in argument, but assign drinking privileges in conformity with demonstrable inability to perform a biologic function or achieve a preferred emotional release without it. But then ours is not, possibly never has had a genuine desire to be, a completely rationalized society.

The Negro Artist and the Racial Mountain

By LANGSTON HUGHES

ONE of the most promising of the young Negro poets said to me once, "I want to be a poet—not a Negro poet," meaning, I believe, "I want to write like a white poet"; meaning subconsciously, "I would like to be a white poet"; meaning behind that, "I would like to be white." And I was sorry the young man said that, for no great poet has ever been afraid of being himself. And I doubted then that, with his desire to run away spiritually from his race, this boy would ever be a great poet. But this is the mountain standing in the way of any true Negro art in America —this urge within the race toward whiteness, the desire to pour racial individuality into the mold of American standardization, and to be as little Negro and as much American as possible.

But let us look at the immediate background of this young poet. His family is of what I suppose one would call the Negro middle class: people who are by no means rich yet never uncomfortable nor hungry—smug, contented, respectable folk, members of the Baptist church. The father goes to work every morning. He is a chief steward at a large white club. The mother sometimes does fancy sewing or supervises parties for the rich families of the town. The children go to a mixed school. In the home they read white papers and magazines. And the mother often

Written at Lincoln University, Spring, 1926.

says "Don't be like niggers" when the children are bad. A frequent phrase from the father is, "Look how well a white man does things." And so the word white comes to be unconsciously a symbol of all the virtues. It holds for the children beauty, morality, and money. The whisper of "I want to be white" runs silently through their minds. This young poet's home is, I believe, a fairly typical home of the colored middle class. One sees immediately how difficult it would be for an artist born in such a home to interest himself in interpreting the beauty of his own people. He is never taught to see that beauty. He is taught rather not to see it, or if he does, to be ashamed of it when it is not according to Caucasian patterns.

For racial culture the home of a self-styled "high-class" Negro has nothing better to offer. Instead there will perhaps be more aping of things white than in a less cultured or less wealthy home. The father is perhaps a doctor, lawyer, landowner, or politician. The mother may be a social worker, or a teacher, or she may do nothing and have a maid. Father is often dark but he has usually married the lightest woman he could find. The family attend a fashionable church where few really colored faces are to be found. And they themselves draw a color line. In the North they go to white theaters and white movies. And in the South they have at least two cars and a house "like white folks." Nordic manners, Nordic faces, Nordic hair, Nordic art (if any), and an Episcopal heaven. A very high mountain indeed for the would-be racial artist to climb in order to discover himself and his people.

But then there are the low-down folks, the so-called common element, and they are the majority—may the Lord be praised! The people who have their nip of gin on Saturday nights and are not too important to themselves or the community, or too well fed, or too learned to watch the lazy world go round. They live on Seventh Street in Washington or State Street in Chicago and they do not particularly care whether they are like white folks or anybody else. Their joy runs, bang! into ecstasy. Their religion soars to a shout. Work maybe a little today, rest a little tomorrow. Play awhile. Sing awhile. O, let's dance! These common people are not afraid of spirituals, as for a long time their more intellectual brethren were, and jazz is their child. They furnish a wealth of colorful, distinctive material for any artist because they still hold their own individuality in the face of American standardizations. And perhaps these common people will give to the world its truly great Negro artist, the one who is not afraid to be himself. Whereas the better-class Negro would tell the artist what to do, the people at least let him alone when he does appear. Whereas the better-class Negro is not afraid of him—if they know he exists at all. And they accept what beauty is their own without question.

Certainly there is, for the American Negro artist who can escape the restrictions the more advanced among his own group would put upon him, a great field of unused material ready for his art. Without going outside his race, and even among the better classes with their "white" culture and conscious American manners, but still Negro enough to be different, there is sufficient matter to furnish a black artist with a lifetime of creative work. And when he chooses to touch on the relations between Negroes and whites in this country with their innumerable overtones and undertones, surely, and especially for literature and the drama, there is an inexhaustible supply of themes at hand.

To these the Negro artist can give his racial individuality, his heritage of rhythm and warmth, and his incongruous humor that so often, as in the Blues, becomes ironic laughter mixed with tears. But let us look again at the mountain.

A prominent Negro clubwoman in Philadelphia paid eleven dollars to hear Raquel Meller sing Andalusian popular songs. But she told me a few weeks before she would not think of going to hear "that woman," Clara Smith, a great black artist, sing Negro folksongs. And many an upper-class Negro church, even now, would not dream of employing a spiritual in its services. The drab melodies in white folks' hymnbooks are much to be preferred. "We want to worship the Lord correctly and quietly. We don't believe in 'shouting.' Let's be dull like the Nordics," they say, in effect.

The road for the serious black artist, then, who would produce a racial art is most certainly rocky and the mountain is high. Until recently he received almost no encouragement for his work from either white or colored people. The fine novels of Chestnutt go out of print with neither race noticing their passing. The quaint charm and humor of Dunbar's dialect verse brought to him, in his day, largely the same kind of encouragement one would give a sideshow freak (A colored man writing poetry! How odd!) or a clown (How amusing!).

The present vogue in things Negro, although it may do as much harm as good for the budding colored artist, has at least done this: it has brought him forcibly to the attention of his own people among whom for so long, unless the other race had noticed him beforehand, he was a prophet with little honor. I understand that Charles Gilpin acted for years in Negro theaters without any special acclaim from his own, but when Broadway gave him eight curtain calls, Negroes, too, began to beat a tin pan in his honor. I know a young colored writer, a manual worker by day, who had been writing well for the colored magazines for some years, but it was not until he recently broke into the white publications and his first book was accepted by a prominent New York publisher that the "best" Negroes in his city took the trouble to discover that he lived there. Then almost immediately they decided to give a grand dinner for him. But the society ladies were careful to whisper to his mother that perhaps she'd better not come. They were not sure she would have an evening gown.

The Negro artist works against an undertow of sharp criticism and misunderstanding from his own group and unintentional bribes from the whites. "O, be respectable, write about nice people, show how good we are," say the Negroes. "Be stereotyped, don't go too far, don't shatter our illusions about you, don't amuse us too seriously. We will pay you," say the whites. Both would have told Jean Toomer not to write "Cane." The colored people did not praise it. The white people did not buy it. Most of the colored people who did read "Cane" hate it. They are afraid of it. Although the critics gave it good reviews the public remained indifferent. Yet (excepting the work of DuBois) "Cane" contains the finest prose written by a Negro in America. And like the singing of Robeson, it is truly racial.

But in spite of the Nordicized Negro intelligentsia and the desires of some white editors we have an honest American Negro literature already with us. Now I await the rise of the Negro theater. Our folk music, having achieved world-wide fame, offers itself to the genius of the great in-

Founded in 1917 by **Asa Phillip Randolph** and **Chandler Owen**, *The Messenger* was foremost among African American intellectual journals of the Harlem Renaissance to connect the fate of African Americans with that of the working classes.

Owen and Randolph had run an employment agency for black workers during World War I, and they reported regularly on labor issues. The federal government dubbed *The Messenger* "the most dangerous of all the Negro publications" because of its support for labor organization and the Bolshevik Revolution.[16] In addition to news reporting, the magazine featured poetry by **Langston Hughes**, **Countée Cullen**, and **Claude McKay**, a frequent contributor, as well as essays and short fiction by **Jessie Fauset**, sociologist **E. Franklin Frazier**, **Paul Robeson**, **Wallace Thurman**, and literary critic and historian **J.A. Rogers**. It reached its peak circulation of 20,000 in 1920.

Two of *The Messenger's* most popular features were **Theophilus Lewis's** dramatic criticism and **George S. Schuyler's** "Shafts and Darts" column, which pointed its barbs at many eligible topics of the day, but reserved its very best satire for the New Negro movement, as in his August 1926 "Ballad of Negro Artists": "Cannot we alleged writers and singers and such, / Playing on 'racial differences,' cash in as much?" Schuyler created his own monthly award, a "beautiful cutglass thunder-mug," usually for the most foolish snippet of news journalism he could find. He became managing editor in the mid-1920s, after Owen resigned.

In August 1925, at the behest of a group of Pullman porters, Randolph issued a call for the organization of sleeping car porters and waiters. He announced his intention to use *The Messenger* to spread word of the organization to all potential members:

This is only the beginning of the biggest fight ever waged in the interest of downtrodden, exploited, starved, and enslaved Negro workers. This important and clarion call must and will reach every Pullman porter in the United States and Canada. Special newsdealer rates to Pullman porters. Send in for bundle orders of five or more, or send us the name and address of any newsdealer handling Negro publications around any railroad station, anywhere. Help us to help break the grip of the Pullman Company on the throats of its most faithful workers! Spread the news!

The next month, Randolph began printing membership forms for the union in *The Messenger*. Though they fought for over a decade, the Brotherhood of Sleeping Car Porters eventually won recognition from the Pullman Company and membership in the American Federation of Labor, becoming the first union organized by African Americans to do so.

9

The Messenger
1917–1928

James Weldon Johnson Memorial Collection

[Body text of page 288 — two columns of prose, illegible at this resolution]

(Continued on page 307)

PULLMAN PORTERS NEED OWN UNION

By A. PHILIP RANDOLPH

The Pullman porters are unorganized. They are the only workers on the railroads unorganized. Of course they are a part of the Company's Plan of Employee's Representation. But this is the Company's union. The Negro officials of the union have no rights which the Company is bound to respect. This fact is fully and clearly shown by a number of cases adjusted under the Employee's Representation Plan. It is merely calculated to impress the Porters with the idea that they have a union when in reality they only have a fake union, a sham, a union which is of no earthly benefit to them because it is owned and controlled body and soul by the Pullman Company.

[Remainder of article text — two columns, largely illegible]

Free Assemblage of Porters Banned

[article continues]

Shafts & Darts
A Page of Columny and Satire

By GEORGE S. SCHUYLER

The Grubiat of Ima Kalehound

Translated from the Ullivine

[Poem and columns of satirical verse and prose — largely illegible at this resolution]

(Continued on next page)

Ain't gonna play no second fiddle 'cause I'm used to playin' lead.

Perry Bradford, "Ain't Gonna Play No Second Fiddle," sung by Bessie Smith

ENTERTAIN

A story in itself so amazing that George C. Wolfe decided to create a musical-within-a-musical about it in 2016, *Shuffle Along* could hardly have seemed less likely to succeed. Created by two veteran vaudeville duos—the comedy team **Flournoy Miller** and **Aubrey Lyles** and the musical team **Eubie Blake** and **Noble Sissle**—the venture was financed by the four performers from their vaudeville earnings. After previews in African American theaters in Washington and Philadelphia, the show—by then $18,000 in debt—secured an opening for May 1921 on the very edge of Broadway, at the decrepit Sixty-Third Street Music Hall. In spite of an unenthusiastic notice in the *New York Times,* before long it was so thronged with customers that **James Weldon Johnson** would write in *Black Manhattan* that the show forced "the Traffic Department to declare Sixty-Third Street a one-way thoroughfare."[17] The show would run for a staggering 504 performances on Broadway, then tour for an additional two years, netting enormous profits.

With an unremarkable plot, *Shuffle Along* would be chiefly remembered for its songs, which included such hits as "I'm Just Wild about Harry" and "Gypsy Blues," as well as its dancing. Advertised as "the speediest, breeziest, funniest musical comedy" and "the world's greatest dancing show," it is credited with reinventing the musical chorus line as a group of dancers, typically women, who perform fast-paced, synchronous movements, rather than standing in place in elaborate costumes.[18] Of the chorus, **Heywood Broun** wrote in characteristically pithy fashion, "No musical show in town boasts such rousing and hilarious teamwork. Even a Yale crew could well be proud of such an *espirit de corps*. They would die for 'Shuffle Along,' each last one of them, and so great is the frenzy and vigor of some of the dancing that one wonders that they don't."[19]

Employing a cast of sixteen principals and thirty-two singers and dancers, *Shuffle Along* opened opportunities for some of the finest African American performers. The list of those whose careers were advanced by *Shuffle Along* includes **Florence Mills** and **Josephine Baker**, as well as composers **Hall Johnson** (who conducted the orchestra), and **William Grant Still** (who played oboe). **Langston Hughes** would repeatedly cite *Shuffle Along* as the event that inaugurated the Harlem Renaissance (and first drew him to New York). *Shuffle Along* would also open an era of black musical comedy on Broadway, inspiring dozens of revues and musical comedies.

10

Various Songs from *Shuffle Along*
M. Witmark & Sons
1921

James Weldon Johnson Memorial Collection

SHUFFLE ALONG

THE N...

THE...

GYPSY BLUES

LOVE WILL FIND A WAY

THE...

...ING CO. Inc. Offers

...NOVELTY SUCCESS

I'M JUST WILD ABOUT HARRY

(HARRY)

SHUFFLE ALONG, Inc. Presents

THE NEW YORK MUSICAL NOVELTY SUCCESS

Shuffle Along

Along

Book by
Flournoy
Miller
and
Aubrey
Lyle

Baltimore Buzz	60
Bandana Days	60
Daddy Won't You Please Come Home	60
Everything Reminds Me of You	60
Gypsy Blues	60
Good Night, Angeline	60
Honeysuckle Time	60
I'm Just Wild About Harry	
If You've Never Been Vamped By a Brown Skin	60
I'm Craving for That Kind of Love	60
I'm Just Simply Full of Jazz	60
Kentucky Sue	60
Love Will Find a Way	60
Liza Quit Vamping Me	60
Low Down Blues	60
Old Black Joe and Uncle Tom	60
Oriental Blues	60
Pickaninny Shoes	60
Shuffle Along	
Vision Girl	

Lyrics & Music by
Noble
Sissle
and
Eubie
Blake

Lyrics & Music by
Noble
Sissle
and
Eubie
Blake

60
60
60
60
60
60
60
60
60
60
60
60
60
60
60

OPERATIC EDITION

OPERATIC EDITION

M. Witmark & Sons
New York

Printed in U. S. A.

Though her voice was never recorded, many contemporary critics argued that **Florence Mills** was the greatest singer of her generation—a generation that included **Bessie Smith**, **Gertrude "Ma" Rainey**, and **Ethel Waters**. Contemporaries who heard her sing likened Mills's voice to bubbles, bells, a flute, a bird, anything light and diminutive. Her signature song, "I'm a Little Blackbird Looking for a Bluebird," included the lyrics "I'm a little jazz-bo looking for a rainbow too / building fairy castles, just like all the white folks do," suggesting that African Americans were entitled to the same dreams as whites.

Mills was just as notable for her comedic talent and dancing as for her voice. As theater critic **Theophilus Lewis** wrote in *The Messenger*, "She has perfect control of both the technique of restraint and the technique of abandon. [...] My God! man, I've never seen anything like it! Not only that, I never imagined such a tempestuous blend of passion and humor could be poured into the singing of a song. I never expect to see anything like it again, unless I become gifted with second sight and behold a Valkyr riding ahead of a thunderstorm. Or see Florence Mills singing another song."[20] Photographed here by the famed **Edward Steichen** for *Vanity Fair* in her costume from *Dixie to Broadway*, a vaudeville-inspired revue, Mills appears starkly lit with a sharp shadow, but comedically dressed in the hat and bindle of a hobo, the classic costume of a clown.

Mills's career reflects the trajectory of African American popular performance in the early decades of the twentieth century. Born in 1895 in Washington, D.C., Mills made her professional debut at the age of eight in **Bert Williams** and **George Walker's** *Sons of Ham.* Though she was arrested and barred from performing for being underage, Mills had discovered the tutelage of "cakewalk queen" **Aida Overton Walker**, wife of George Walker. Aida Walker mentored a succeeding generation of female performers. By 1910, Mills was living in Harlem and had formed a vaudeville act with her sisters, dubbed The Mills Sisters. For the next decade, she toured the country performing in a variety of vaudeville venues, including in Chicago with **Bill "Bojangles" Robinson**.

It wasn't until 1921 that Mills got her great break, cast to replace **Gertrude Saunders** as Ruth Little, one of the principals in *Shuffle Along*, the first Broadway musical with an all-African American cast. There, she caught the eye of **Lew Leslie**, owner of Broadway's Plantation Restaurant and eventual theater producer. Leslie cast Mills in his first attempt at an all-black Broadway revue, *Dixie to Broadway*. After the success of Leslie's *Plantation Revue*, he renamed his legendary *Blackbirds* revue in honor of Mills's theme song "I'm a Little Blackbird." A tremendous success in New York, *Blackbirds* toured Paris, Belgium, and London, registering over 250 performances.

Mills's career was tragically cut short when she died of appendicitis (some historians believe tuberculosis and exhaustion) in 1927 at the age of 31. Some reports estimated that 150,000 people packed the streets of Harlem at her funeral.

11

Edward Steichen, Portrait of Florence Mills
1924

James Weldon Johnson Memorial Collection

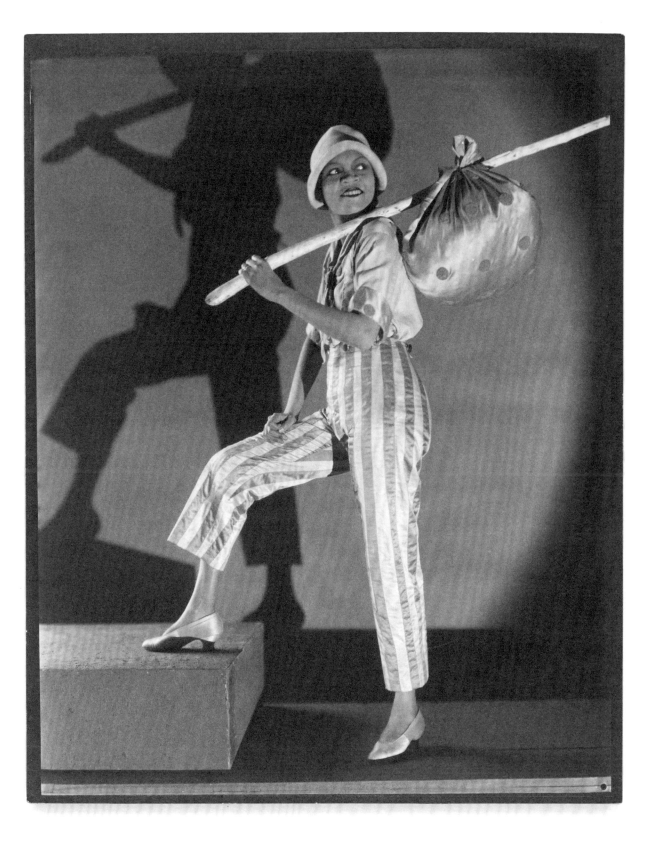

As **Langston Hughes** always noted, the "vogue" for all things Negro in Manhattan began on the stage, not only with musical theater performances like *Shuffle Along,* but also with "legitimate" dramatic performances of plays by white playwrights **Ridgley Torrence**, **DuBose and Dorothy Heyward**, and **Eugene O'Neill**. Torrence's trio *Three Plays for a Negro Theater*, which included the J.M. Synge-esque folk tragedy *Granny Maumee*, opened in Madison Square on April 5, 1917, with an African American cast recruited from Harlem's Lafayette Players (it had been performed a few years earlier with a white cast). In his history *Black Manhattan*, **James Weldon Johnson** would recall the date as "the most important single event in the entire history of the Negro in the American theatre; for it marks the beginning of a new era."[21] No longer would African Americans be portrayed only by degrading stereotypes; Torrence's plays were the first to offer realistic depictions of black life. Moreover, Torrence's plays, the Heywards' *Porgy*, and O'Neill's African American plays were hailed as the advent of a new, truly American theater, and marked the arrival of modern American drama.

The relationship among O'Neill, the Provincetown Players, and African American performers exemplifies the link between Harlem and the intellectual and creative life of Greenwich Village. Following Torrence's critical success, O'Neill began to explore using African American characters in his plays, beginning with *The Dreamy Kid* in 1918. *The Emperor Jones* (1920), starring **Charles Gilpin** as the eponymous Pullman-porter-turned-ruler of a small island in the West Indies, became O'Neill's first major hit.

When the Provincetown Players began to prepare O'Neill's *All God's Chillun Got Wings* (1923), they were contacted by a young man with a law degree and an interest in pursuing theater. **Paul Robeson** had dabbled on the stage previously, but this would be his first major professional production. The play was not without controversy, however: it portrayed an interracial marriage and the psychological toll that racism could take on a relationship. When word spread that Robeson would kiss white actress **Mary Blair** on the hand in the play, O'Neill and other producers of the play received threats from the Ku Klux Klan. New York City major John F. Hylan refused to issue permits for child actors to appear on stage during the first scene, temporarily postponing the opening of the play. Ironically, the move served Robeson's career: he was hastily cast in a revival of *The Emperor Jones* to fill the gap. Robeson would go on to star as Brutus Jones in the film adaptation of the play as well. O'Neill would be invited to serve as a judge in several African American literary contests, including both the *Crisis* and *Opportunity* contests.

Remembered best for his resonant baritone singing voice, Robeson's acting career was groundbreaking. He would go on to redefine the role of Shakespeare's *Othello*, becoming the first African American to play the Moor on a major American stage. **Carl Van Vechten** befriended Robeson (claiming credit for having introduced him to the Provincetown Players), and Van Vechten collected dozens of photographs of Robeson for the James Weldon Johnson Memorial Collection. These include photographs documenting Robeson's extensive world travels, many of them taken by his wife **Eslanda Goode Robeson**, as well as portraits of Robeson with his son Paul Robeson, Jr., known as "Pauli."

12

Program, *All God's Chillun Got Wings*
1924

Clippings File of the James Weldon Johnson Memorial Collection

Photographs of Paul Robeson
1925–1937

James Weldon Johnson Memorial Collection

PROVINCETOWN PLAYBILL

A Leaflet Issued with Each New Production at the Provincetown Playhouse—Season 1923-24 No. 5

A Congo Mask

ALL GOD'S CHILLUN GOT WINGS

A Play in Two Acts
By EUGENE O'NEILL
Directed by James Light
Settings by Cleon Throckmorton

Scene 1

Jim Harris	William Davis
Ella Downey	Virginia Wilson
Shorty	George Finley
Joe	Malvin Myrck
Mickey	Jimmy Ward
Little Girls	Grace Burns, Alice Nelson, Evelyn Wynn

Remaining Scenes

Jim Harris	Paul Robeson
Mrs. Harris, his mother	Lillian Greene
Hattie, his sister	Dora Cole
Ella Downey	Mary Blair
Shorty	Charles Ellis
Joe	Frank Wilson
Mickey	James Martin
Organ Grinder	James Meighan
Salvationists	Barbara Benedict, Clement O'Loghlen, John Taylor

Men and Women............Kirk Ames, Harold Bryant, Hume Derr, Oscar Flanner, Lila Hawkins Paul Jones, Spurgon Lampert, Sadie Reynolds Kathleen Roarke, James Shute, Leslye Thomas

Act I: Scene 1—A corner in lower New York. Years ago. End of an afternoon in Spring.

Scene 2—The same. Nine years later. End of an evening in Spring.

Scene 3—The same. Five years later. A night in Spring.

(Continued on page 6)

TRAGEDY

BY JOHN MASEFIELD

TRAGEDY at its best is a vision of the heart of life. The heart of life can only be laid bare in the agony and exultation of dreadful acts. Commonplace people dislike tragedy, because they dare not suffer and cannot exult. The truth and rapture of man are holy things not lightly to be scorned. A carelessness of life and beauty marks the glutton, the idler, and the fool in their deathly path across history.

The poetic impulse of the Renaissance is now spent. The poetic drama, the fruit of that impulse, is now dead. Until a new poetic impulse gathers, playwrights trying for beauty must try to create new forms in which beauty and the high things of the soul may pass from the stage to the mind. Our playwrights have all the powers except that power of exultation which comes from a delighted brooding on excessive, terrible things.

That power is seldom granted to man; twice or thrice to a race perhaps, not oftener. But it seems to me certain that every effort, however humble, towards the achieving of that power helps the genius of a race to obtain it, though the obtaining may be fifty years after the strivers are dead.

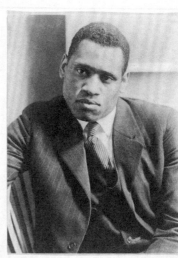

To Carl Van Vechten.
In appreciation of his interest
and understanding and most of
all his friendship.
Paul Robeson.

2
R 54

As **Irving Berlin** put it in his immortal (and dated) 1927 lyrics, "If you're blue / And you don't know where to go to / Why don't you go where Harlem flits / Puttin' on the Ritz." By the end of the 1920s, Harlem's entertainments were legendary, attracting patrons from downtown and out of town, to the dismay of some residents above 110th Street. In 1929 *Variety* published a list of eleven night clubs that catered to white patrons, with the top three being The Cotton Club, Connie's Inn, and Small's Paradise—of these, only Small's admitted African American customers.[22] Even in the capital of black America, African Americans found themselves protesting segregation (**Carl Van Vechten** boycotted The Cotton Club after being refused admission with an interracial group).

E. Simms Campbell's *Night-Club Map of Harlem*, published in January 1933 in the short-lived *Manhattan: A Weekly for Wakeful New Yorkers*, organizes itself around the triangle of The Cotton Club at 644 Lenox Avenue in the lower-right, Connie's Inn at 2221 Seventh Avenue at top-left, and Small's at 2294 ½ Seventh Avenue at right. Other venues line streets so tightly jammed that 110th jumps to 131st, and 142nd is packed in *south* of 138th. Oriented with north pointing to the lower-right, the map approaches Harlem from an angle most downtown readers weren't used to seeing. **Cab Calloway**, whose band succeeded **Duke Ellington's** orchestra at The Cotton Club in 1931, sings his famous "ho-de-hi-de-ho"; **Bill "Bojangles" Robinson** and **Gladys Bentley** make appearances, as does anatomy-defying dancer **Earl "Snake-hips" Tucker** at the Savoy Ballroom, known as the "Home of Happy Feet."

Part entertainment, part actual guide, the map counsels guests at Club Hot-cha not to go before 2 a.m. and to "Ask for Clarence." The fried chicken at Tillie's gets a special endorsement—"it's really good!"

Meanwhile, the gags abound: a crush of taxis carries lavishly attired downtowners to Connie's. A man throws his top-hat out of a window to a couple on the sidewalk dressed to go out in everything but. Pairs in every part ask each other, "What's the number?"—including the police playing cards at the new station—in reference to racketeer-run lottery games.

A graduate of the Art Institute of Chicago, Campbell furnished illustrations for many newspapers and magazines of the time, including *Opportunity*, *The New Yorker*, *Life*, *Collier's, Saturday Evening Post*, *The Pittsburgh Courier, Cosmopolitan,* and *Playboy*. He joined *Esquire* as a staff illustrator in 1934, and his feature "Cuties" was syndicated in dozens of newspapers. Though most of his illustrations did not feature African American characters or themes, Campbell illustrated **Sterling Brown's** *Southern Road* (1932) and **Langston Hughes** and **Arna Bontemps's** children's book *Popo and Fifina: Children of Haiti* (1932).

13

E. Simms Campbell, *Night-Club Map of Harlem* 1932

James Weldon Johnson Memorial Collection

and tickles the ivories

or heav

S

W

E

hats de
mumbah? =
"Its $.35

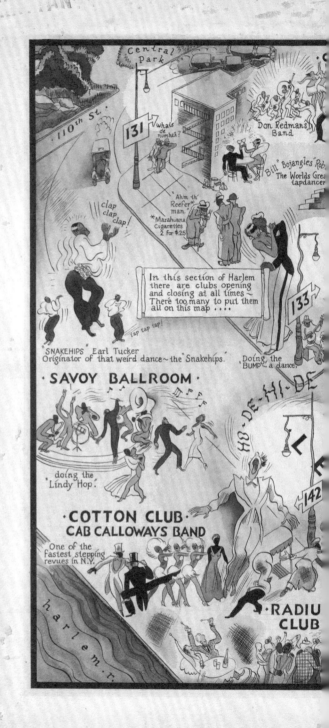

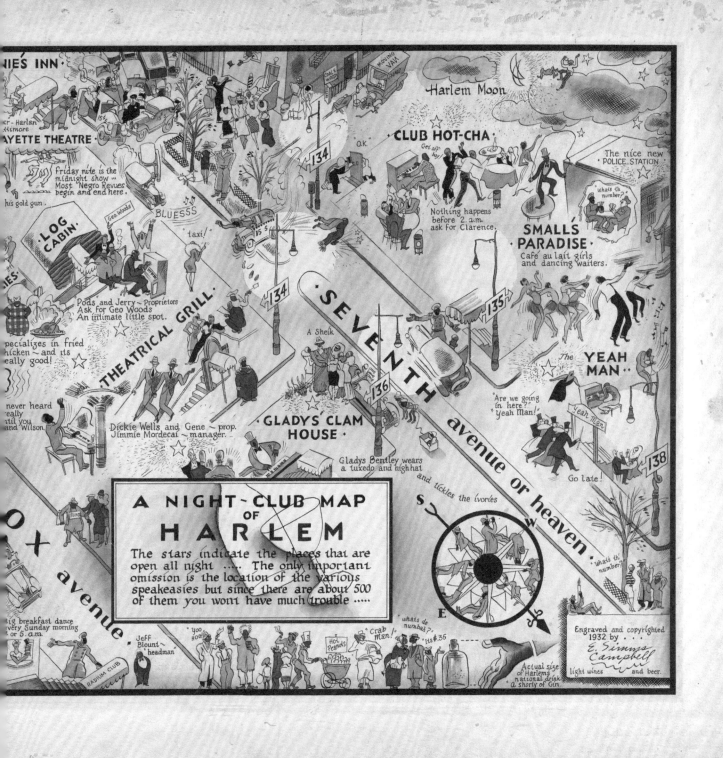

A NIGHT~CLUB MAP
OF
HARLEM

The stars indicate the places that are open all night The only important omission is the location of the various speakeasies but since there are about 500 of them you wont have much trouble

Engraved and copyrighted 1932 by E. Simms Campbell

Dozens of photographic postcards collected primarily by **Carl Van Vechten** document the many guises and wide-ranging celebrity appeal of **Josephine Baker**. The cards hint at the extent to which Baker's image circulated after she catapulted to stardom in the early 1920s. Not only were these images collectible, but the fact of their being postcards that could be sent through the mail serves as a nice figure for Baker's transatlantic appeal. Photographed in several of Paris's most popular studios, including Walery, Gaston and Henri Manuel, and Studio Piaz, as well as by several Paris-based émigrés, including Austrian-Jewish Dora Kallmus ("Madame d'Ora"), the Russian Boris Lipnitzki, and the American Arthur O'Neill, the Baker postcards encapsulate modernism's celebration of technology and the so-called primitive alike.

Born in St. Louis in 1906, Baker found her first job in show business as a dresser for **Clara Smith** on the touring circuit. At fifteen, she was hired to join the chorus line in the touring company of *Shuffle Along*. Garnering attention and praise as the comedic end-girl who messed up all the steps and then performed virtuosically, Baker was given a special part in *Chocolate Dandies* (1924) and then recruited to appear in *La Revue Nègre* in Paris, where she opened October 1925. Her *danse sauvage*, performed topless with feathered accessories around her head, waist, and ankles, shocked and delighted Parisian audiences, fueling the Parisian craze for jazz and all things African American. Starring at the Folies-Bergère and frequently outdoing her own audacity, Baker next appeared in a skirt made entirely of bananas. In 1928-29, she toured twenty-five European countries.

Though historians are torn on the question of whether Baker played into or took advantage of the primitivist and exoticist expectations of her audiences, it's clear that her fame enabled her to have a positive impact overall. In 1937, she became a French citizen; during the Second World War, Baker assisted the French Resistance. For her efforts, she was awarded a Croix de Guerre, Légion d'Honneur, and Rosette of the Résistance. Baker used her celebrity to protest segregation in the United States, as well, refusing to perform in Jim Crow theaters. Beginning in 1953, foreshadowing the behavior of future celebrities, Baker adopted twelve children from all over the world, whom she referred to as her "Rainbow Tribe" and raised in the belief that she could demonstrate interracial unity in her own family. Baker was one of the only women invited to speak at the 1963 March on Washington.

14

Postcards of Josephine Baker
ca. 1925–1935

James Weldon Johnson Memorial Collection

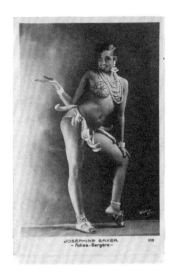

JOSÉPHINE BAKER
-Folies-Bergère-

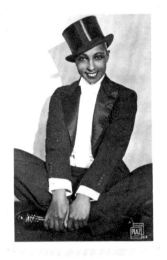

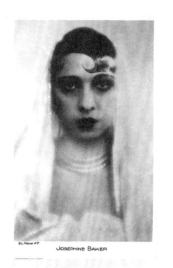

JOSEPHINE BAKER

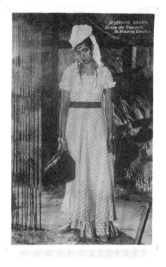

JOSEPHINE BAKER
"Sirène des Tropiques"
de Maurice Dekobra

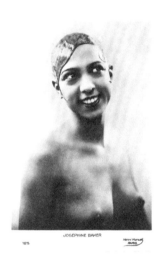

JOSÉPHINE BAKER

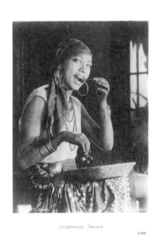

JOSÉPHINE BAKER

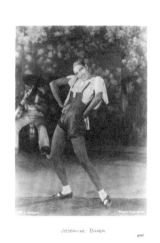

JOSEPHINE BAKER

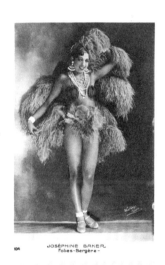

JOSÉPHINE BAKER
-Folies-Bergère-

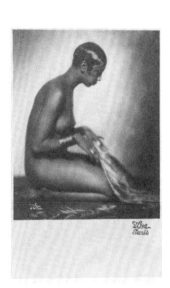

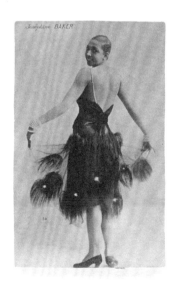

Joséphine BAKER

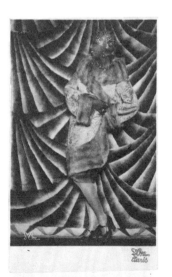

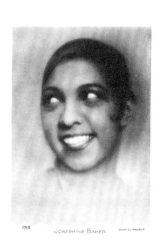

JOSEPHINE BAKER

Before he became the first half of the **George and Ira Gerswhin's** famous 1936 opera, Porgy (sans Bess) was born in a 1925 novel by South Carolinian **DuBose Heyward**. Heyward's wife **Dorothy Heyward** adapted the novel into a play in 1927, and it was produced by the Theatre Guild. Both Heyward's novel and the stage version were praised by critics for offering a never-before-seen depiction of the lives of African Americans in the Gullah communities in Charleston. Of this culture's grit, vice, and religious fervor, Heyward wrote in a preface to the printed edition of the play:

> Slowly, as I watched and listened, there grew within me the conviction that this life which was going on within our own, yet was apart from it, possessed a certain definite, but indefinable quality that remained with my own people only in a more or less vestigial state, and at times seemed to have departed altogether like our gills and tails. From admiration of the manifestations of this secret law my feeling grew to one of envy; and so, from the beginning, my approach to the subject was never one of pity for, or philanthropic urge to succour, an unfortunate race. I saw the primitive Negro as the inheritor of a source of delight that I would have given much to possess. Why, then, should I weep over him? [23]

Heyward added that "the presentation of the play with a Negro cast, two years after publication of the novel, represents a much closer approximation of an artistic ideal."

The Theatre Guild production, directed by **Rouben Mamoulian** in his Broadway debut, with a stunningly detailed realistic depiction of Catfish Row designed by **Cleon Throckmorton**, opened at the Guild Theatre in October 1927. It ran for 217 performances before going on tour in 1928 throughout the United States. It returned to Broadway in September 1929, only to have its run cut short by the crash of the stock market.

Though Crown's Bess appears in the play as Porgy's tragic love interest, the starring roles in the 1927 production were **Rose McClendon's** widow Serena and **Georgette Harvey's** Maria. The play also starred veteran African American performers **Frank Wilson** (Porgy) and **Jack Carter** (Crown). Like the plays of **Eugene O'Neill** on a much larger scale, Porgy represented one of the first opportunities for these actors, many of them veterans of Harlem's Lafayette Theatre, to play serious dramatic roles on a major stage. The cast was enormous, as illustrated by their photograph in front of the Apollo Theatre in Atlantic City. **Richard Bruce Nugent**, as Richard Bruce, joined the chorus along with **Wallace Thurman** in response to an open casting call for black performers in 1927. At center, incongruously situated behind Porgy's goat, Rose McClendon sits regally dressed in a turban and raccoon fur coat. Nugent, one of the many non-speaking "Fishermen, Stevedores, etc." in the cast, stands two rows behind her.

15

Advertisement for the Theatre Guild's *Porgy*
1927

Theatre Guild Archive

Photograph of the Cast of *Porgy*, Atlantic City, New Jersey
1929

Richard Bruce Nugent Papers

THE THEATRE GUILD PRESENTS

PORGY

A FOLK PLAY

BY DUBOSE & DOROTHY HEYWARD

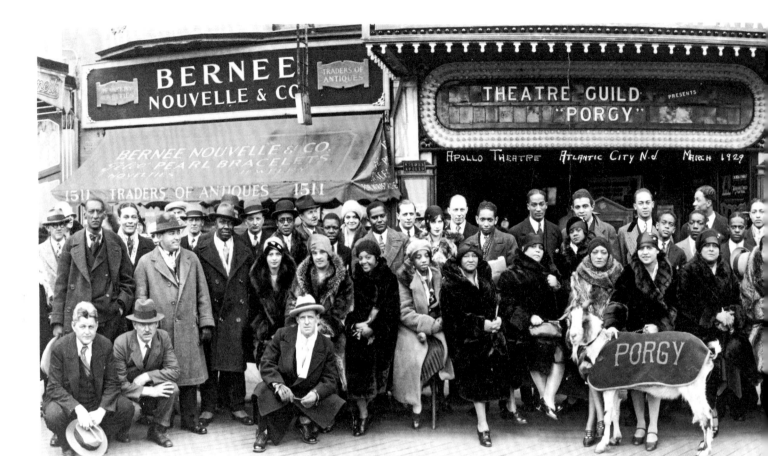

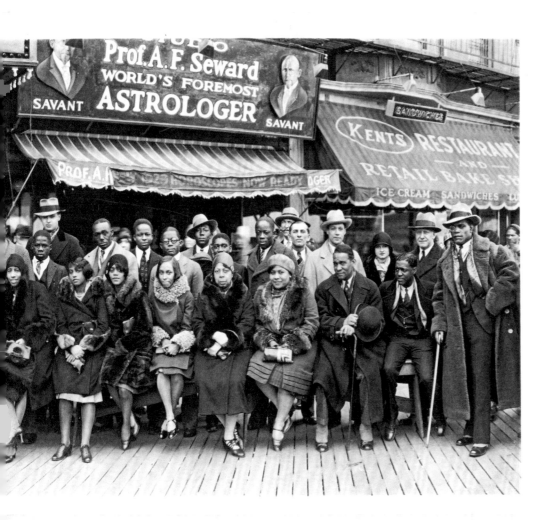

A true Renaissance man, **James Weldon Johnson** may be better remembered today, as his biographer Eugene Levy notes, "as the author of *God's Trombones* than as the guiding force behind the Dyer anti-lynching bill."[24] Yet Johnson, the namesake of Beinecke's collection of African American literature, juggled political action and artistic creation as executive secretary of the N.A.A.C.P. The story of the inspiration for *God's Trombones: Seven Negro Sermons in Verse* is typical in demonstrating the intersection of Johnson's political work and his poetic inspiration. Johnson recounted the story of his inspiration in a preface to the volume. Throughout 1918, he toured towns to organize N.A.A.C.P. chapters. In Kansas City, he was to give a talk after an evangelical preacher who dazzled him by performing a traditional folk sermon—of the kind Johnson grew up hearing. With a style that blended African American vernacular language and Old Testament tradition, "He strode the pulpit up and down in what was actually a very rhythmic dance, and he brought into play the full gamut of his wonderful voice, a voice—what shall I say?—not of an organ or a trumpet, but rather of a trombone, the instrument possessing above all others the power to express the wide and varied range of emotions encompassed by the human voice—and with greater amplitude. He intoned, he moaned, he pleaded—he blared, he crashed, he thundered." Johnson began to sketch out "The Creation" before the pastor's sermon had ended.

Aaron Douglas painted seven illustrations for the seven "sermons" of *God's Trombones*, his first major book project. With his characteristic silhouetted, slit-eyed figures, inspired by a blend of the geometry of art deco and the profiles of Egyptian art, Douglas represents the Prodigal Son literally beset from all sides by Harlem's dangerous enjoyments: gambling, liquor, women. Inscribing a copy to his friend **Carl Van Vechten**, Johnson wrote humorously, "I hope you will ponder as well as peruse these 'sermons.' I call your special attention to the preachments and the precepts contained in 'The Prodigal Son,' or, as it might be called, 'The Red Hot Mamas of Babylon.'" As they appear in "The Prodigal Son," Babylon and its "Red Hot Mamas" may be more of an inducement to vice than a warning against it:

> And he spent his days in the drinking dens,
> Swallowing the fires of hell.
> And he spent his nights in the gambling dens,
> Throwing dice with the devil for his soul.
> And he met up with the women of Babylon.
> Oh, the women of Babylon!
> […]
> And he wasted his substance in riotous living,
> In the evening, in the black and dark of night,
> With the sweet-sinning women of Babylon.

In a *Time* magazine review praising the volume, Douglas was hailed as a "race futurist."[25] He would go on to decorate the cover of Johnson's reissued novel *The Autobiography of an Ex-Coloured Man*, as well as a dozen more books.

16

Aaron Douglas, "Prodigal Son" (artwork for *God's Trombones*)

James Weldon Johnson and Grace Nail Johnson Papers

The career of **Ethel Waters** intersects interestingly with those of both **Florence Mills** and **Josephine Baker**, suggesting something of the variety of paths available to black female performers in this time. Waters auditioned for *Shuffle Along* in 1921 but was turned down, while Mills was a principal in the show and Baker a chorus girl; Waters eventually replaced Mills at **Lew Leslie's** Plantation Club in 1925, refusing the part in *Revue Nègre* that made Baker famous. And Waters's career as an artist in media beyond the stage—in sound recordings and film—would outstrip those of both Mills and Baker.

Born in 1896, Waters escaped a brutal and tumultuous childhood in Chester, Pennsylvania, to begin performing in Baltimore music halls in 1917, eventually joining the Theatre Owners Booking Association or "TOBA" circuit. (The acronym TOBA was glossed by some participants as "Tough on Black Actors"—or "Asses.") Waters later recalled, "I used to work from nine until unconscious. I was just a young girl and when I tried to sing anything but the double-meaning songs they'd say 'Oh, my God, Ethel, get hot!'"[26] With the stage nickname "Sweet Mama Stringbean," Waters honed a singing voice often described as restrained, in direct contrast to the uninhibited moans of **Bessie Smith** or **Gertrude "Ma" Rainey**. **Carl Van Vechten** argued that Waters's style was a "refined" take on the other blues women. Her approach would influence later jazz singers like **Ella Fitzgerald** and **Billie Holiday**.

In 1921, **Harry Pace** of the new Black Swan Records hired Waters to record "Down Home Blues" and "Oh Daddy" for $100. Following closely on the heels of **Mamie Smith's** groundbreaking blues records, these songs became hits and were followed by more; Waters recorded over 250 songs over the course of her career, including her signature "His Eye Is on the Sparrow," "Stormy Weather," "Dinah," and "Am I Blue?" In 1925 she joined Leslie's *Plantation Revue,* and made her way from revue and concert-style performances to more involved acting roles. Her first straight dramatic performance was in **Du Bose and Dorothy Heyward's** 1939 *Mamba's Daughters*. She went on to star in *Cabin in the Sky* (1940, film 1942) and **Carson McCullers's** *Member of the Wedding* (1950, 1952), in a role she would reprise into her seventies. In 1949 she became the second African American after **Hattie McDaniel** to be nominated for an Academy Award for her performance in *Pinky*—playing the grandmother of the title character, a role that had almost been offered to Waters's sometime rival **Lena Horne**.

Van Vechten and Waters met backstage after a performance and quickly became lifelong friends—Waters uses a variety of playful salutations in her letters to Van Vechten, including "Darling pal" and "My Nordic lover." She is among Van Vechten's most photographed subjects, with over one hundred portraits captured in sittings spanning decades. Van Vechten also collected numerous portraits of Waters done by others, several of them inscribed to him. On a portrait in which she wears a feathered skirt and headdress, Waters writes, "To Carl Van Vechten, Ethel Waters now dressed to go back where I stayed last nite & shake that thing so 50 more million Frenchmen can go wrong."

17

Photographs of Ethel Waters
ca. 1925–1927

James Weldon Johnson Memorial Collection

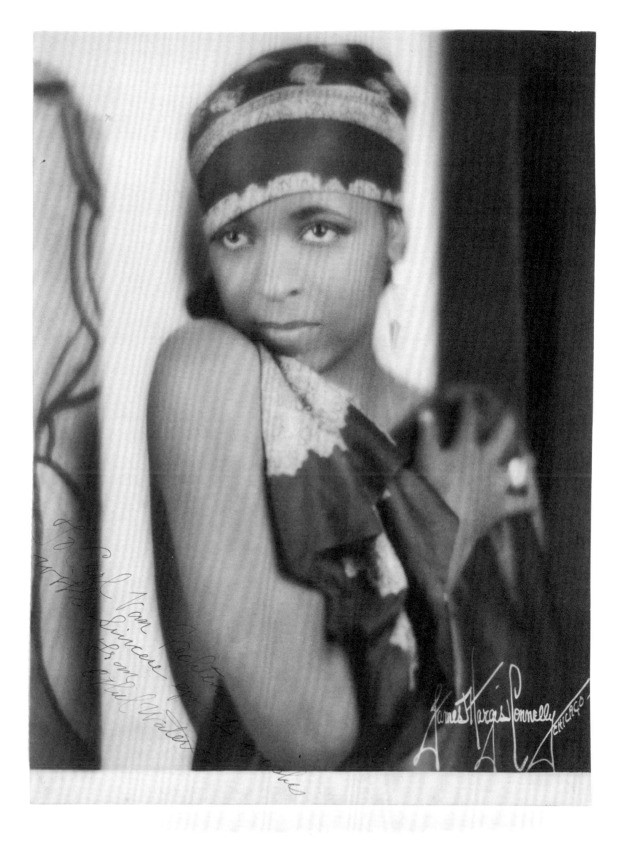

By the time he was named Mayor of Harlem in 1933, **Bill "Bojangles" Robinson** was over fifty years old and had been entertaining people for nearly all of that half-century. Born in 1878 and given the name Luther Robinson, Bojangles would come to symbolize black popular performance, for better and sometimes for worse. Like **Florence Mills**, Robinson had his start in theater as a child, performing on the vaudeville circuit as a "pick" or "pickaninny" stock character. He appeared in the landmark African American musical *The South Before the War* in 1892. Though he had already by this time acquired his famous nickname "Bojangles," Robinson also dropped the name Luther and adopted his younger brother's name, Bill—or so he told everyone. Most details of Robinson's life before 1892 come from Robinson's own account.

The most celebrated tap dancer of his time—if not universally believed to be the best—Robinson tried to join the National Vaudeville Artists' Association, but he was denied on account of his race. Robinson pursued equal treatment for African American performers throughout his career, and was founding honorary president of the Negro Actors Guild in 1936. Though some critics charged Robinson with undermining racial progress by portraying stereotypically buffoonish characters, his endorsement of the Negro Actors Guild and other efforts suggest his commitment to equality. He is often recognized as the first African American comedic performer to appear onstage without blackface makeup.

Like several other Harlem Renaissance figures, including **George S. Schuyler**, Robinson served in the United States Army during World War I. After the war, he settled in New York, though he still toured frequently. Perhaps surprisingly, Robinson's Broadway debut did not arrive until 1928, when **Lew Leslie** asked him to rescue his *Blackbirds* revue three weeks after its lukewarm premiere. This photograph, inscribed to **Carl Van Vechten**, dates from that time. Robinson signs the note "copeseticly," an adverb version of the word that came into vogue in the 1920s and which Robinson claimed to have invented, meaning "fine," "OK," or "satisfactory." Van Vechten helped to popularize the word with its use in his 1926 novel of Harlem, *Nigger Heaven*. A Latinate-sounding mouthful with a very plain meaning, "copacetic" (as it is now typically spelled) is characteristic of the language spoken by a stock figure of blackface minstrelsy, the dandy or Zip Coon. Yet, unlike that language, which was designed to caricature and denigrate African American vernacular speech, Robinson's word turns that tradition on its head. Thus, though Bojangles often seemed to be on the verge of prolonging the minstrel tradition, he instead embraces and upends it simultaneously.

One of the highest paid African American performers of his time, Robinson made a fortune, particularly once he broke into Hollywood, co-starring in a series of films with child actress **Shirley Temple**. Between a generosity of legendary proportions and a gambling habit, however, Robinson died without a penny to his name in 1949. Friends ensured that he received a memorial service worthy of his stature: his service was performed by Reverend **Adam Clayton Powell, Sr.**, and New York mayor William O'Dwyer eulogized him.

18

Photograph of Bill Robinson inscribed to Carl Van Vechten
1928

James Weldon Johnson Memorial Collection

Just a few "Taps"
for a dear friend
of mine —
Mr Carl Van Vechten —
"Copesetiely"
Bill Robinson
Blackbirds of 1928 —

Perhaps no other single photograph stands as quite the same icon of Harlem's glamour in the 1920s as this portrait by **James Van Der Zee**. Wearing matching raccoon fur coats and posed against their gleaming automobile, this couple radiates modernity and telegraphs "cool" decades before that adjective would come into fashion.

Remembered as the photographer of Harlem, Van Der Zee was born in Lenox, Massachusetts, in 1886. At 20, he moved to New York and, aside from a brief stint in Virginia, he remained there the rest of his long life. A photography hobbyist from the young age of 14, Van Der Zee was largely self-taught, with the exception of a year working as a darkroom assistant at a department store studio in Newark, New Jersey. Van Der Zee left that position to open his own studio, Guarantee Photos, at 109 West 135th Street in Harlem, in 1916. There, members of Harlem's growing African American middle class would hire Van Der Zee to take studio portraits. By the early 1930s, Van Der Zee had moved his operation to GGG Studio, named for his second wife Gaynella, at 272 Lenox Avenue, where the Van Der Zees also lived.

Van Der Zee's portraits are chiefly remembered for their romantic trappings and quasi-painterly effects, including the occasional use of backdrops, soft focus, double exposure, scratching, and retouching, among other techniques. He was also a masterful printer (this print in the James Weldon Johnson Collection was created from Van Der Zee's 1932 negative in 1974 by the photographer Richard Benson). Appointed the official photographer of **Marcus Garvey's** Universal Negro Improvement Association, Van Der Zee shot the great majority of his subjects in his studio, including spiritual leader **Father Divine**, performers **Bill "Bojangles" Robinson** and **Florence Mills**, Reverend **Adam Clayton Powell, Sr.**, his son Congressman **Adam Clayton Powell, Jr**. and his daughter **Blanche Powell**, and beauty product magnate **Madame C. J. Walker** and her daughter **A'Lelia Walker**. Van Der Zee did, however, also occasionally photograph people he simply came across—as he did with this couple—particularly for inclusion in his promotional calendars.

As do-it-yourself photography became more affordable, Van Der Zee's business declined. In 1960, he was evicted from his home and studio, and by 1967 he was living in poverty. Then, his work was featured in the Metropolitan Museum of Art exhibition "Harlem on My Mind." Though the show achieved a certain notoriety for its poor reception, the attention resuscitated Van Der Zee's career. Despite losing his home, Van Der Zee had saved 75,000 prints, negatives, and glass plates. In subsequent years he enjoyed several major exhibitions. This photograph is from a special edition portfolio of his work issued in 1974.

19

James Van Der Zee, *Couple*
1932
Printed for *Eighteen Photographs*, Graphics International Ltd. 1974

James Weldon Johnson Memorial Collection

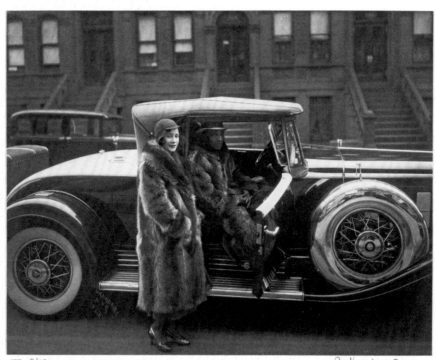

Though he adopted the title "Father of the Blues," **William Christopher Handy** never went so far as to claim he had invented blues. Nevertheless, a title more like *finder* of the blues might have been more apt, for Handy was instrumental in bringing the blues out of the rural south to a much larger audience—one that may not have encountered this essential form of American music without him. Born the child of two former slaves in Florence, Alabama, in 1873, the great arranger taught himself to play cornet in secret because his devout father forbade musical instruments from the home. In his 1941 autobiography, Handy claimed a lifelong interest in sound and the musicality of the world around him, beginning with birdsong; *Father of the Blues* bears a virtual soundtrack of the noises of his life. He recounts how he and his friends made instruments, both real and pretend, out of whatever was available: a penny nail and a horse's jawbone, a broom handle, a comb, their own bodies.[27]

Handy was already 30 years old by the time he settled in Clarksdale, Mississippi, in the heart of the delta, with a new wife and young children. It was there that, ever attentive to the sounds around him, he began to learn the blues from traveling the countryside and listening to itinerant performers. He incorporated this tradition into his own compositions of then-popular ragtime. Eventually, he moved his family to Memphis and made his way into the Beale Street music scene. In 1912, his composition "Memphis Blues" became a hit—but he had sold his copyright to the printer for just $50. Determined not to repeat that mistake, Handy formed his own sheet music company with lyricist **Harry Pace**: the Pace and Handy Music Company. In 1914, their "St. Louis Blues" became Handy's greatest hit, and the Pace and Handy Company enjoyed a string of successes. A few years later, Handy settled in Harlem.

In 1926, Handy published a songbook of blues arrangements titled *Blues: An Anthology*. Published by **Albert and Charles Boni**, the book was illustrated by **Miguel Covarrubias**, the Mexican caricaturist. Handy subsequently gave copies of Covarrubias's portrait to friends as souvenirs; the James Weldon Johnson Collection holds three inscribed copies. This one, for **Langston Hughes**, acknowledges Hughes's poem "The Weary Blues," published that year in a volume bearing the same name, with cover art also by Covarrubias.

A nineteen-year-old Covarrubias had arrived in New York City in 1923 on a visit sponsored by the Mexican Ministry of Foreign Relations. He would stay for more than a decade. In September he met **Carl Van Vechten**, who introduced him to *Vanity Fair* editor **Frank Crowninshield**. Covarrubias became one of the magazine's lead illustrators and continued to contribute even after a merger with *Vogue* in 1936. Described as "postcubist" by some art historians, Covarrubias's drawings and caricatures became recognizable for a humor, sympathy with his subject, and use of line that would influence **Al Hirschfeld** and French poster artist **Paul Colin**.[28] Indeed, in part to assuage objections to past racist depictions of African Americans such as those of Currier and Ives, Covarrubias insisted that the portraits published in his 1927 book *Negro Drawings* were not caricatures. The artist would develop friendships and working relationships with many African American writers in addition to Handy and Hughes, including **James Weldon Johnson** and **Zora Neale Hurston**, whose book *Mules and Men* (1935) he illustrated.

20

Miguel Covarrubias, Drawing of W.C. Handy inscribed by Handy to Langston Hughes
1926/1932

Langston Hughes Papers

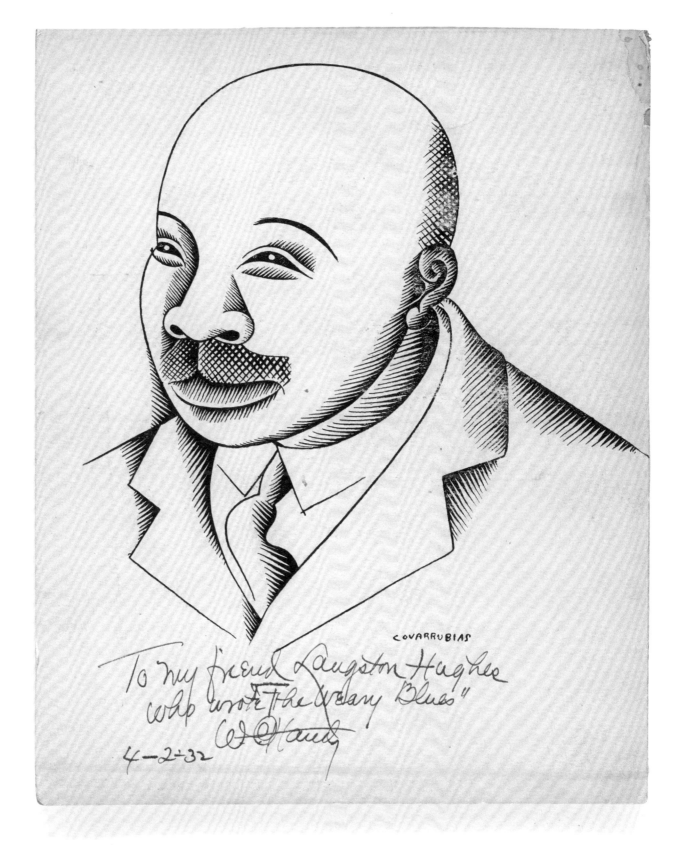

To my friend Langston Hughes
who wrote "The Weary Blues"
W C Handy
4—2—32

COVARRUBIAS

A prolific author of fiction, poetry, film and television, jazz history, and cookbooks, the writer and artist **Stephen Longstreet** contributed cartoons and drawings to *The New Yorker*, *Vanity Fair*, *Saturday Evening Post*, and *Colliers*. Born Chauncey Weiner in 1907, Longstreet worked under several names and settled on Stephen Longstreet, the latter an anglicization of the family name Longstrasse, in his mid-30s.

A lifelong jazz aficionado, Longstreet recalled seeing **Paul Robeson** sing as a child growing up in New Brunswick, New Jersey, when Robeson was still a football star at Rutgers University. He credited this experience with sparking his interest in African American music. Longstreet's Harlem sketchbook (disbound into individual sheets by the time it arrived at Beinecke Library), includes watercolor, ink, and pencil drawings completed in the 1920s and 1930s, based on observations in both Harlem and New Orleans. These drawings capture something of the spirit and dynamism of dances and musical performances that Longstreet observed—though it is unlikely that the drawings were done from life (some of them date from much later, into the 1950s).

Longstreet's sketches celebrate musicians like **"Bunk" Johnson** and **Louis Armstrong**, as well as the many influential dances invented or popularized in the cabarets and on the stages of Harlem during this period. The Charleston, named after its reputed source in South Carolina, was first shown to New York in 1922's musical *Liza,* but it wouldn't become a national sensation until seen in 1923's *Runnin' Wild*. Within two years, the *New York Times* would report, "Debutantes are practicing it at the Colony Club; society matrons are panting over it in Park Avenue boudoirs; department store clerks are trying to master it in the restrooms at the lunch hour; the models of the garment industry dance it together in the chop suey palaces at noontime; the flats of the West Side and the tenements of the East Side are not immune to the contagion. [...] Proprietors of employment agencies are being importuned to supply cooks, waitresses, laundresses and maids 'who can Charleston.'" [29]

The kicking leg movements and swinging arms of the dance inspired a name for the newly fashionable young woman, dressed with a hemline to allow for dancing: the flapper. Another dance, the black bottom, debuted in the Broadway show *Dinah* in 1924; others would follow, including the shimmy, the hootchi-cootchi, and the Lindy Hop, the last named for Charles Lindbergh's 1927 transatlantic flight.

In Harlem's clubs, speakeasies, and rent parties, the dances delighted dancers and onlookers alike. Longstreet's sketches offer a perspective on Harlem nightlife from a type of outsider who has gained a certain notoriety: the voyeuristic white patron traveling uptown on a Saturday night. But they still succeed in giving those of us who missed the party a glimpse of what it might have looked like.

21

Stephen Longstreet, Harlem Sketchbook
1925–1939

Stephen Longstreet Papers

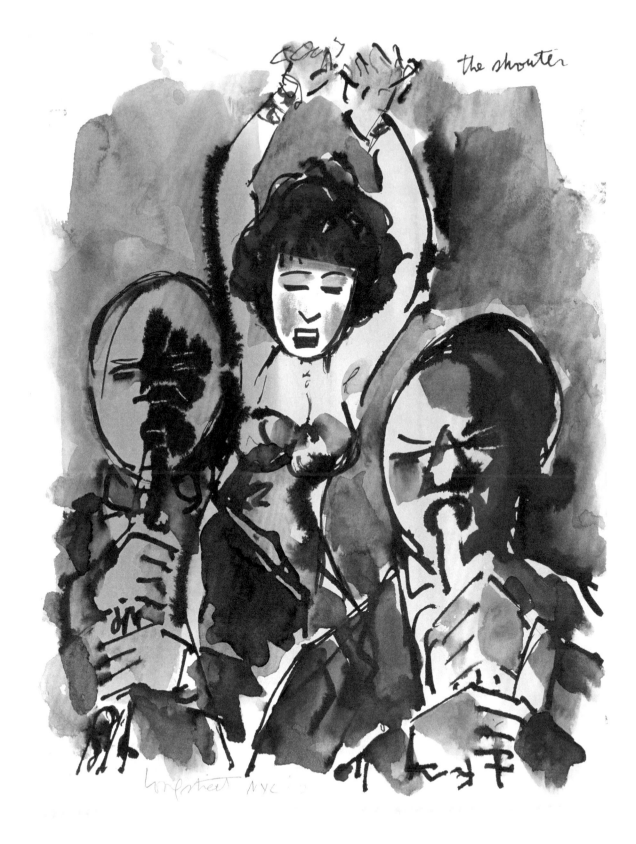

the shouter

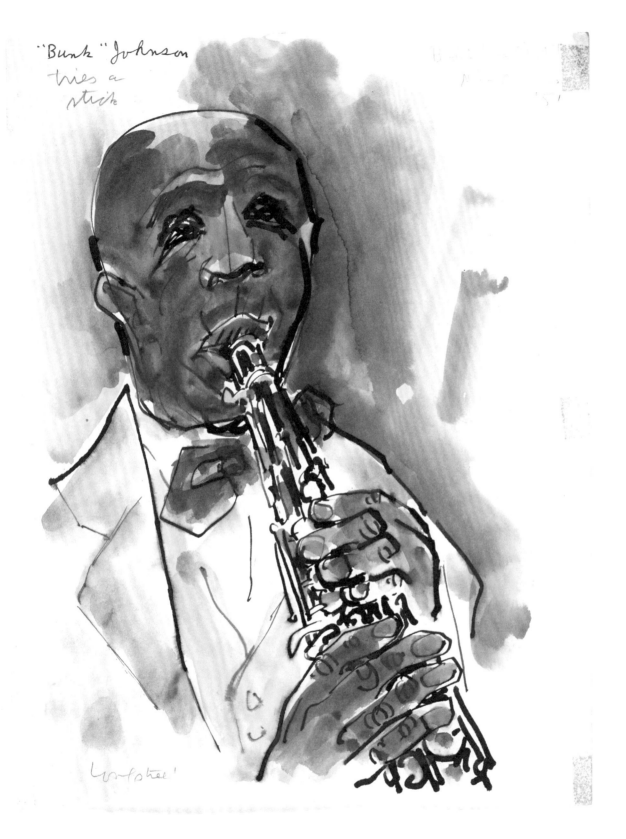

"Bunk" Johnson
tries a
stick

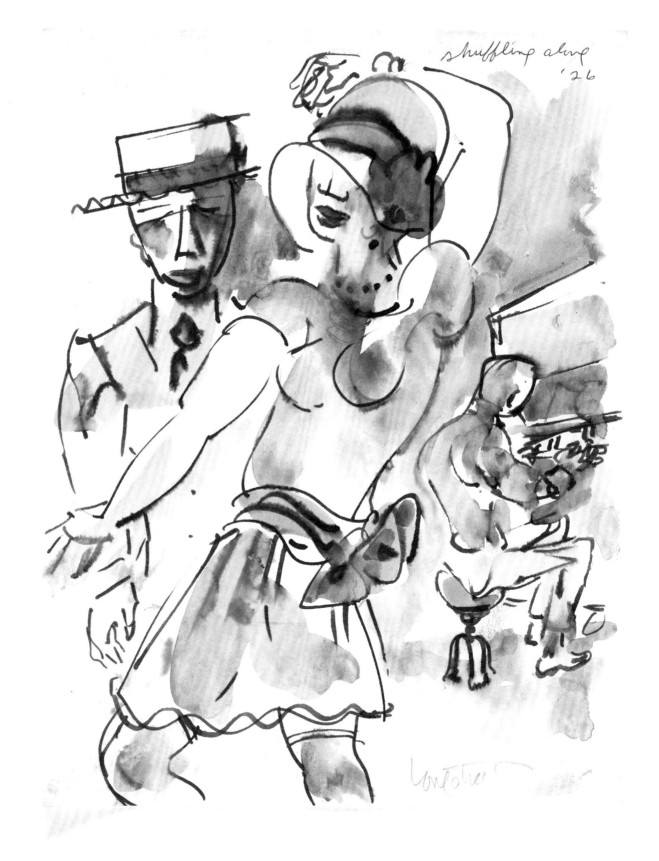

shuffling along
'26

The people who have their nip of gin on Saturday nights and are not too important to themselves or the community, or too well fed, or too learned to watch the lazy world go round. They live on Seventh Street in Washington or State Street in Chicago and they do not particularly care whether they are like white folks or anybody else. Their joy runs, bang! into ecstasy. Their religion soars to a shout. Work may be a little today, rest a little tomorrow. Play awhile. Sing awhile. O, let's dance!

Langston Hughes, "The Negro Artist and the Racial Mountain"

GET TOGETHER

Given the enormity of the event that became of the dinner at the Greenwich Village Civic Club in late March 1924, **Charles Johnson's** note to **Jean Toomer** strikes a remarkably understated tone. "A group of some of the younger writers, which includes **Eric Walrond**, **Jessie Fauset**, **Gwendolyn Bennett**, **Countée Cullen**, **Langston Hughes**, **Alain Locke**, and some others, plans a rather informal dinner meeting, around the twentieth of this month, to which are being invited about fifty persons: **Eugene O'Neill**, **H. L. Mencken**, **Oswald Garrison Villard**, **Mary Johnston**, **Zona Gale**, **Robert Morse** [sic] **Lovett**, **Carl Van Doran** [sic], **Ridgeley** [sic] **Torrence**, and about twenty more of this type."

Toomer declined the invitation, but over a hundred people attended the dinner, on March 21. Their ostensible purpose was to celebrate Jessie Fauset's new novel *There is Confusion*, but Johnson had taken this pretense to organize a symposium on the new "contributions" of "younger" African American writers (at 41 the literary editor of *The Crisis*, Fauset was hardly a "younger" writer, nearly ten years older than Johnson and twenty years older than Langston Hughes).

The Civic Club had opened in 1917 on 12th Street, just off Fifth Avenue, and was the only upscale social club that allowed interracial gatherings. The location, as well as the guest list, serve as a reminder of the revolving door between Uptown and Downtown in this period. American cultural modernism could be seen as the flirtation, if not the marriage, of Harlem and Greenwich Village. Still, interracial didn't mean equal: most of the black dinner guests paid for their meals at Johnson's Civic Club event, whereas the whites did not.[30]

The duties of master of ceremonies for the evening were turned over to **Alain Leroy Locke**, the accomplished professor of philosophy from Howard University. Fauset found herself and her novel taking a backseat to speeches by *Century* magazine editor Carl Van Doren, publisher **Horace Liveright**, **Walter White**—whose own novel *Fire in the Flint* would be published by **Alfred A. Knopf** shortly thereafter—Locke's Howard colleague drama critic **T. Montgomery Gregory**, and art collector **Albert Barnes**. Countée Cullen and Gwendolyn Bennett read poetry. As the event wound to a close, the momentum Charles Johnson had tried to generate paid off: **Paul Kellogg**, editor of *Survey* magazine, proposed to do a special graphic number devoted to the Negro. It would be published in March of 1925.

Between events like the Civic Club Dinner, the later *Opportunity* prize dinners, and his editorship of *Opportunity*, Charles Johnson is often credited with orchestrating the Renaissance from behind the scenes. Johnson shared his mentor **Robert Park's** pragmatic approach to cultural change, believing that changes in material circumstances would stem from changes in attitudes.[31] He cited literature by and about African Americans as "useful," writing that literature could "force the interest and kindred feeling of the rest of the world by sheer force of the humanness and beauty of one's own story."[32] With an ability to produce the appearance of inevitability—what David Levering Lewis memorably calls "artifice imitating likelihood"—Johnson set the Renaissance in motion.[33]

Johnson's letter to Toomer bears stamps from the Fisk University Library. Toomer's papers, long on deposit at Fisk, were donated to Yale University by his family in 1980. The story of this collection is suggestive of the complicated history of African American documents and of who may steward that history.

22

Charles S. Johnson, Dinner invitation to Jean Toomer
March 6, 1924

Jean Toomer Papers

L. HOLLINGSWORTH WOOD
Chairman

EUGENE KINCKLE JONES
Executive Secretary

CHARLES S. JOHNSON, Editor

OPPORTUNITY

PUBLISHED BY

The Department of Research and Investigations

NATIONAL URBAN LEAGUE

127 EAST 23rd STREET, NEW YORK CITY

Telephone Gramercy : 3978

WILLIAM H. BALDWIN
Secretary

A. S. FRISSELL
Treasurer

March 6, 1924.

Mr. Jean Toomer,
115 West Tenth Street,
New York City.

Dear Mr. Toomer:

 A group of some of the younger writers, which includes Eric Walrond, Jessie Fauset, Gwendolyn Bennett, Countee Cullen, Langston Hughes, Alain Locke, and some others, plans a rather informal dinner meeting, around the twentieth of this month, to which are being invited about fifty persons: Eugene O'Neill, H. L. Mencken, Oswald Garrison Villard, Mary Johnston, Zona Gale, Robert Morse Lovett, Carl Van Doran, Ridgeley Torrence, and about twenty more of this type. I think you might find this group interesting, at least enough so to draw you away for a few hours from your work on your next book. The idea originated with a proposal of a much smaller meeting around the date of the appearance of Miss Fauset's novel, "There Is Confusion", and grew to include all of the younger writers who have been making substantial contributions. This note is more an inquiry than an invitation and it seeks merely to learn if you could find time around that date and the disposition to come out.

 Sincerely,

Charles S. Johnson,
Editor.

CSJ/MGA

The first African American woman to become a self-made millionaire through her line of hair and beauty products, **Madame C. J. Walker** died in 1919, leaving her daughter **A'Lelia Walker Robinson** at the helm of her beauty empire, as well as properties up and down the Hudson. Finding neither Villa Lewaro, the Irvington-on-Hudson estate, nor the double brownstone at 108-110 West 136th Street sufficiently cozy, A'Lelia repaired to an apartment at 80 Edgecombe Avenue. The 136th Street property, which had been designed by African American architect **Vertner Woodson Tandy** and served as the Walkers' Harlem residence and the headquarters of the company, was given over to the Walker Beauty Parlor, College, and Spa.

The elegantly appointed reception room, pictured here, welcomed groups of women for tea and discussion. The photograph, signed in the negative by **James Van Der Zee**, exhibits some of Van Der Zee's experiments with double exposure and trompe l'oeil printing. The back of the photograph bears Van Der Zee's G.G.G. Studio stamp—when this photograph was taken Van Der Zee had just moved from his 135th Street studio, just a block away, to one further down Lenox Avenue.

Though wealthy and generous, A'Lelia Walker initially admired the cultural movement from the wings. David Levering Lewis sardonically notes, "She received most of the Harlem artists and sent them congratulatory notes, but spent the Renaissance playing bridge." (**Richard Bruce Nugent**, on the other hand, recalled poker to have been her game.)[34] In 1927, Walker announced to a group of writers gathered for dinner at 136th Street her plans to convert part of the expansive building to a salon for writers and artists. The venue would be named "The Dark Tower," after **Countée Cullen's** poem and *Opportunity* literature

column. Nugent later recalled numerous committee meetings planning a space to be designed and decorated by the artists themselves, where they could meet, eat cheaply or gratis, and share ideas. What came to fruition surprised and disappointed Nugent upon his arrival at the 1928 gala opening: "One of the artists was nearly refused admission because he had come with an open collar and worn no cravat, but fortunately someone already inside recognized him, and he was rescued." That artist, presumably Nugent himself, went on to discover prices decidedly out of reach: ten cents for coffee, twenty-five cents for lemonade, and twenty-five to fifty cents for sandwiches. "He left hungry."[35]

Harold Jackman's memory was perhaps more generous. Recalling the salons in 1952, he said: "One couldn't help being impressed with the brilliance of the evenings [...] Literature, politics, painting and music were always discussed. Something interesting was constantly happening. Madame Walker made certain that there was always more than enough elegant dishes and drinks to go around."[36]

The Wall Street crash took a toll on the Walker empire's fortunes, and the Dark Tower was shuttered. Eventually, however, the same stretch of 136th Street became home to the regional branch of the New York Public Library that abuts the Schomburg Center for Research in Black Culture. Fittingly, the branch is named for the author of "The Dark Tower" himself, Countée Cullen.

23

James Van Der Zee, *The Valentine Tea at Walker Shop #1*
1929

James Weldon Johnson Memorial Collection

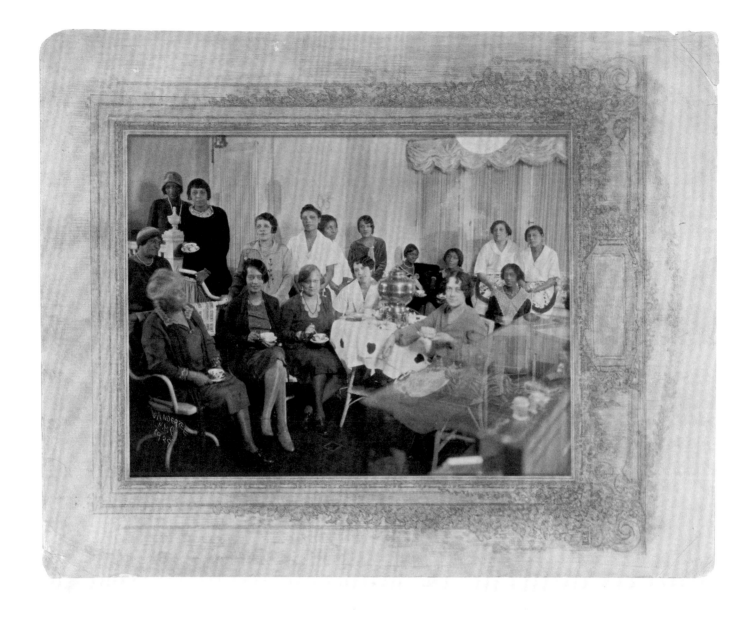

A Harlem Renaissance fellow traveler of sorts, **Harold Jackman** was best friends with **Countée Cullen** (they met while students at the storied DeWitt Clinton High School) and the model for **Winold Reiss's** famous portrait "A College Lad," which appeared in the *Survey Graphic* Harlem number and *The New Negro*. When **Carl Van Vechten** founded the James Weldon Johnson Memorial Collection, Jackman helped to secure many donations, while he also made a number of his own, including several wonderful groups of letters.

The letters to Jackman from poet and artist **Gwendolyn Bennett** date from Bennett's year in Paris from 1925-1926. She traveled there to study art on a scholarship from the Alpha Sigma Chapter of the Delta Sigma Theta Sorority, and spent her year between Académie Julian, Académie Colorassi, and École de Pantheon.

Bennett, who had read her poem "To Usward" at the 1924 Civic Club Dinner, had been born in Texas in 1902 and studied fine art at Pratt, where she graduated in 1924, taking a teaching position at Howard University. Her perspective on the budding Renaissance from across the pond provides news and insight into events in both places. In September 1925, she writes, "Please write to me and tell me all the news as well as the scandal. What do you know about Countée [Cullen], Frank Horne and Langston [Hughes] capturing all the poetry prizes in the Crisis contest?[…] Send me Countée's book [*Color*]—I'll pay you for it when I get back to America. You're working now and that two or three dollars won't break you. Also Langston's [*The Weary Blues*] when it comes out. Those are the only two I care about. The others can wait."

While Bennett asks Jackman to keep her apprised of the literary scene in Harlem, she shares the broader scene of modernism with him. At his request, she secured and disguised a copy of James Joyce's *Ulysses* to send back to him in the United States, where it would remain banned until 1933. She met Ernest Hemingway, who had just emerged with the story collection *In Our Time*—his first book to be published in the United States, to much acclaim. Bennett initially refers to Hemingway as "Alan" when she describes him in a dispatch to Jackman as "a charming fellow—big and blustery with an out-doors quality about him coupled with a boyishness that makes him just right." She is far more star-struck when she has dinner with Henri Matisse.

Bennett writes that she has entered twelve things in the 1926 *Opportunity* prize contest, and also wants more information about the Boni brothers' novel contest (even though she had not yet published any fiction). She hopes Jackman will send her a copy of "Dr. Locke's book," *The New Negro*, for the "ungodly" price of $5 (she had not been included among the ten poets published in it). Desperate for validation of her work, she writes, "All I need to do is get one poem published in a good white magazine to make me have real confidence in myself." Twenty-two of Bennett's poems appeared in journals between 1923 and 1931.

24

Gwendolyn Bennett, Letters to Harold Jackman 1925–1926

James Weldon Johnson Collection Files

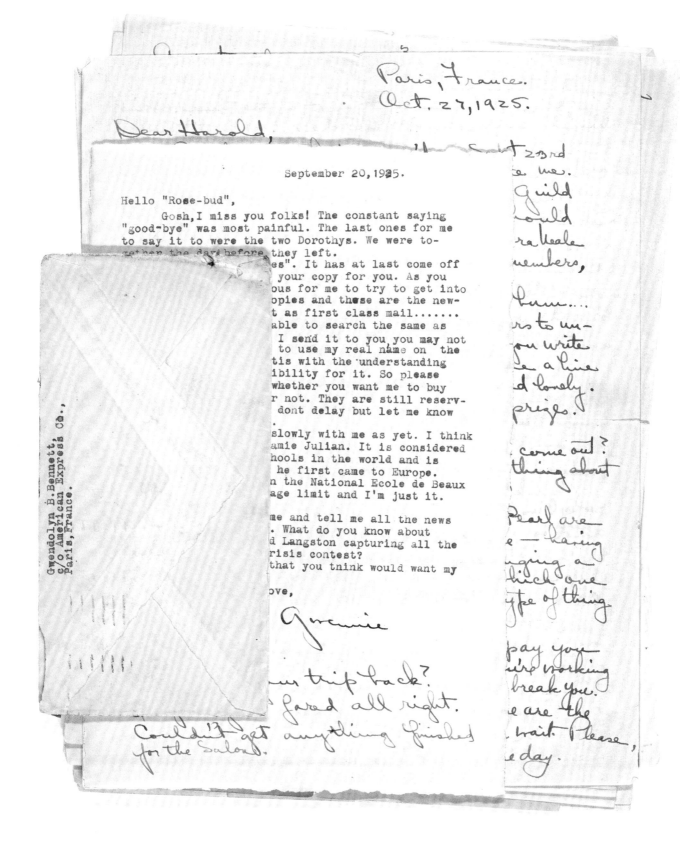

Paris, France.
Oct. 27, 1925.

Dear Harold,

September 20, 1925.

Hello "Rose-bud",

 Gosh, I miss you folks! The constant saying
"good-bye" was most painful. The last ones for me
to say it to were the two Dorothys. We were to-
gether the day before they left.

es". It has at last come off
your copy for you. As you
ous for me to try to get into
opies and these are the new-
t as first class mail.......
able to search the same as
I send it to you you may not
to use my real name on the
tis with the understanding
ibility for it. So please
whether you want me to buy
r not. They are still reserv-
dont delay but let me know

slowly with me as yet. I think
amie Julian. It is considered
hools in the world and is
he first came to Europe.
n the National Ecole de Beaux
age limit and I'm just it.

me and tell me all the news
. What do you know about
d Langston capturing all the
risis contest?
that you tnink would want my

ove,

Gwennie

ur trip back?
fared all right.
Couldn't get anything finished
for the Salon.

Gwendolyn B.Bennett,
c/o American Express Co.,
Paris, France.

23rd
me.
Guild
ould
ra Heale
members,
hum....
rs to un-
you write
e a line
d lonely.
prizes.

come out?
thing about

Pearl are
e — having
nging a
hich one
type of thing

pay you
're working
break you.
e are the
wait. Please,
e day.

Traveling through the South in the summer of 1927 on **Zora Neale Hurston's** suggestion, **Langston Hughes** began by reading at the commencement of Fisk University in Nashville, Tennessee, visited Memphis and Beale Street for the first time, toured the Toomer plantation which had inspired **Jean Toomer's** *Cane*, witnessed the devastation of one of the worst Mississippi River floods in history, and, in Mobile, Alabama, bumped into his friend Zora. The infamously vivacious Hurston, driving a car she had christened "Sassy Susie," was herself touring the southern states collecting folklore for her mentor **Franz Boas**, the Columbia anthropologist. Hurston and Hughes shared newly discovered blues lyrics and folk tales as they rode together to Tuskegee Institute, where former *Crisis* literary editor **Jessie Fauset** was speaking during the summer session.

With preeminent race leader **Booker T. Washington** as its founding president, Tuskegee had established itself as a top African American institution, particularly in the areas of agricultural and industrial training in keeping with Washington's ethos of African American self-reliance and economic independence from whites. Famously opposed by **W. E. B. Du Bois**, Washington had lost some influence by this death in 1915, which signaled the end of a generation and posed a threat to that generation's so-called accomodationist racial politics. Still, Washington and Du Bois both advocated and were seen as exemplars of African Americans' pursuit of higher education. The monument of Washington at Tuskegee by sculptor **Charles Keck**, dedicated in 1922, bears the inscription, "He lifted the veil of ignorance from his people and pointed the way to progress through education and industry."

Though posed rather stiffly beside the statue, Fauset, Hughes, and Hurston epitomize the contrast between the "younger generation" and Washington, a path-breaker in his day but already coming to be seen as a polarizing and anachronistic figure. As Ralph Ellison would write of the statue years later, "The bronze statue of the college Founder, the cold Father symbol, his hands outstretched in the breathtaking gesture of lifting a veil that flutters in hard, metallic folds above the face of a kneeling slave; and I am standing puzzled, unable to decide whether the veil is really being lifted, or lowered more firmly in place; whether I am witnessing a revelation or a more efficient blinding."[37]

Hughes would later write **Claude McKay**, who himself had briefly attended Tuskegee as a student, of a powerful, but mixed, experience of the college. "You've been to Tuskegee, haven't you? Do you remember the power house dynamo that can be heard at night beating and pulsing like a hidden tom-tom at the heart of the place? And the nice Negroes living like parasites on the body of a dead dream that was alive once for Booker Washington? I want to do an article, or even a novel, about that place."[38]

25

Photograph of Jessie Fauset, Langston Hughes, and Zora Neale Hurston beside *Lifting the Veil* 1927

Langston Hughes Papers

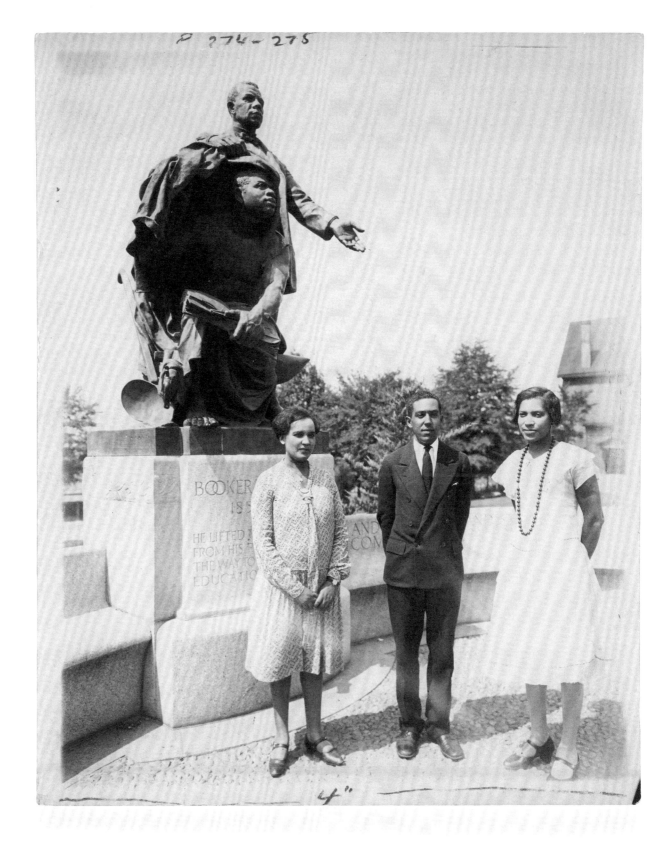

BOOKER

18

HE LIFTED
FROM HIS
THE WAY TO
EDUCATIO

4"

Langston Hughes's biographer Arnold Rampersad writes incisively of the intriguing contrast between friends Langston Hughes and **Countée Cullen**:

> In certain ways Cullen was Hughes's exact opposite. Plain where Hughes was very handsome, he was often a little stiff with strangers where Langston was shy but congenial. Cullen was religious, with a Bible at hand when he composed; Hughes was secular to the bone. As a poet Hughes believed in the power of inspiration and improvisation; Cullen practiced sonnets and villanelles, honed his rhymes, and searched mightily for the exact word. Frowning on free verse and the wild men Whitman and Sandburg, he instead adored John Keats and A. E. Housman. And although he wrote touchingly of race, Cullen found no particular beauty in the black masses, as Hughes did; Africa more or less embarrassed him. While he deeply respected tradition, he saw it as being mainly the European classics. Above all, Cullen wished to be seen not as a Negro poet, but as a poet who happened to be Negro—an attitude Hughes found more than a little perverse.[39]

The twin towers of Harlem poetry, Hughes and Cullen had met shortly after Hughes's arrival in New York in 1921 at one of the many gatherings at the 135th Street Branch Library. Cullen, who had been adopted at seven by Reverend Frederick Asbury Cullen, pastor of Salem Methodist Episcopal Church on Seventh Avenue, had won the city-wide high school poetry competition as a senior at DeWitt Clinton High School, and was then attending New York University. Hughes found himself welcomed at the Cullen family home on 131st Street, which he would use as a waystation on stints in New York after he had withdrawn from Columbia. While he was anchored with the *West Hassayampa* at Jones Point on the Hudson River, Hughes would spend trips to Harlem seeing movies and plays with his friend.

Hughes frequently sent Cullen new poems, some of which Cullen performed on Hughes's behalf at a reading at the 135th Street Library. In the fall of 1923, stopping in New York before setting out on the *McKeesport* for Europe, Hughes left a sheaf of poems with Cullen to be placed in magazines. Writing in May 1924, Cullen indicates that Hughes has sent him another: "I am going to send the poem out immediately." By this time, Hughes had jumped ship in Holland and made his way to Paris.

Referring perhaps to the Civic Club dinner hosted by **Charles S. Johnson**, Cullen writes, "We were all sorry that you were not here for the dinner tendered Miss **[Jessie] Fauset**." He also shares news of a piece in the *Southern Workman* that refers to both young writers: "I was quite proud to have him call us *friends and kindred spirits*." Cullen writes of hoping for Hughes's swift return from overseas, but when Hughes finally did return in the fall of 1924, the pair had a mysterious falling out. Though they would continue to be cordial to one another, and Hughes would appear as an usher in Cullen's 1928 wedding to **Yolande Du Bois**, they would never again share the same warm friendship.

26

Countée Cullen, Letter to Langston Hughes
May 14, 1924

Langston Hughes Papers

734 W. 131 Street,
New York City, May 14, 1924.

Dear Langston,

As you must realize, I was very anxious to receive both your letters and the card you sent me — and especially the poem which I consider, while not the best you have written, especially good, and most naturally adapted to music. You have a pronounced gift of singing and painting in your work. I would really give anything to possess your sense of color. I am going to send the poem out immediately. I am also going to send you copies of Opportunity and the Messenger in which poems of yours appeared. There is no need to send you the Crisis; I suppose Miss Fauset does that.

By the way, have you read Miss Fauset's novel? I haven't had money enough to buy it yet; but I have read Harold's copy, and I like it fairly well. It is certainly a landmark in establishing the intellectual Negro in American literature.

We were all sorry that you were not here for the dinner tendered Miss Fauset, and that given to Dr. Du Bois — especially the latter which was a most brilliant gathering. My table companions were Mary Austin and Walter Hampden. I was impressed with Hampden who was intelligent and gentle humorous. But Mary Austin was a frightful bore — a crabbed old hag. She disgraced herself beyond retribution in her speech by calling us a young race, and dating the origin of the spirituals from the Indians. There were printed programmes upon which I had a poem for the occasion, a poem intending more than it effected. I shall send you a copy.

So you are in love at last? I question its depths, however, when you tell me so resignedly that you are determined that

Sincerely,
Countée

"As for you, I have three wishes—one that you should learn French well, one that you shall write much, and one that you may have whatever happiness possible."

With a B.A. and a Ph.D. from Harvard, the first African American ever to win a Rhodes Scholarship, Howard University professor **Alain Leroy Locke** had yet to become the sage of the Harlem Renaissance when he wrote, demurely, to **Langston Hughes** in 1922: "Everybody it seems who is a particular friend of yours insists on my knowing you. Some instinct, roused not so much by the reading of your verse as from a mental picture of your state of mind, reinforces their insistence." It would be more than a year before the 37-year-old Locke and the 21-year-old Hughes would meet face-to-face, after months of insinuation and outright flirtation. With **Countée Cullen** as their chief intermediary, the young Hughes, freshly withdrawn from Columbia and literally at sea, was happy to have someone to speak to about literature and eager for the benefit to his poetry. As Hughes's biographer Arnold Rampersad writes of Locke, "Locke sometimes seemed more interested in influence through the power of personality—in teaching, university politics and intrigue, and the cultivation of friendships."[40]

Cullen had given Locke Hughes's address at Jones Point on the Hudson River, where Hughes was aboard the *West Hassayampa* as a messman, having boarded the ship in the Battery in search of adventure—and having instead found himself anchored upstate. Eventually, Hughes would voyage down the coast of Africa and from the U.S. to Europe and back, twice. Meanwhile, he maintained himself to be quite ignorant of the love triangle that had arisen between himself, Locke, and Cullen, sending his poems to both and delightedly receiving their feedback. On June 13, 1924, Locke writes, "Countée has shown me *Danse Variation*—I like it so much. I glory in your creativeness. I am so hopelessly academic and sterile, it seems—still I can vibrate once in a while." As Locke labored over the special issue of *Survey* magazine that would evolve into *The New Negro*, he plied Hughes for poems and lamented when he saw one he liked published before it could be included in his landmark anthology.

Though the intensity of their relationship cooled somewhat after the summer of 1924, Hughes and Locke remained close, and Locke introduced Hughes to his patron **Charlotte Osgood Mason** (who was called, at her own insistence, "Godmother"). It was not until Hughes's break with Godmother in 1931—in which Locke played a role—that Hughes and Locke began to correspond with far less frequency.

27

Alain Locke, Letters to Langston Hughes 1922–1931

Langston Hughes Papers

ALAIN LE ROY LOCKE
HOWARD UNIVERSITY
WASHINGTON, D. C.

January 17, 1922

Dear Langston Hughes,

 Everybody it seems who is a particular friend
of yours insists on my knowing you. Some instinct,
roused not so much by the reading of your verse as
from a mental picture of your state of mind, reen-
forces their insistence. I had it as a memo to
look you up on my last visit to New York, and was
disappointed not to find you there. Jesse Fauset,
Contee Cullen are the friends who insist, I think
they ought to be good enough introduction.

 I would have found out where Jones Point is,
and come down or up to it, (it cant very well be in,
can it?) but I did not know where the devil the
Hassayampa might be. It sounds almost as if she went
to Patagonia. By the way a very dear eccentric friend
of mine wrote Sonnets from Patagonia, However, I wasn't
taking any chances chasing a poet on a ship, both
are too elusive, the combination impossible. You
must write me more in detail as to how to get at you
or you will have to remain a rather intriguing phantom,
from whom perhaps an occasional letter comes. If you do
write, and I hope you will, let it be in some consider-
able degree of definiteness and detail. Not ministerial
generalities, but medical particulars,- you get the
idea, I am sure. Eventually certainly there will be
some literary and educational plans to be worked out,
and I would really appreciate a share in them. What is
general race motive in most cases seems singularly

Sincerely
Alain Locke

A sampling of the guests at a 1924 party at **James Weldon and Grace Nail Johnson's** Manhattan apartment illustrates the wide swath of New Yorkers to be found at such a gathering. Familiar Harlem Renaissance figures—**Paul and Eslanda Robeson**, "**The Walter Whites**," **W. E. B. Du Bois**, **Carl Van Vechten and Fania Marinoff**, **Miguel Covarrubias**, **Jules Bledsoe**, *Opportunity* secretary **Ethel Ray Nance**, librarian **Regina Anderson**, **Langston Hughes**, **Gwendolyn Bennett**, **Countée Cullen**, **Jean Toomer**, **Jessie Fauset**—are all accounted for. Yet some unexpected figures also appear: New York Herald Tribune editor **Irita Van Doren**, literary critic **Heywood Broun**, **Mark Van Doren**, and the great civil libertarian **Clarence Darrow**, who would later write of Johnson's novel *The Autobiography of an Ex-Coloured Man*, "It would melt the heart of a stone or a white man—if only stones or white men had hearts."[41]

Several of the Johnsons' guests seem to have been amused at the novelty of a guest register. **Willard Johnson** adds two aliases after his name; N.A.A.C.P. counsel **Arthur Spingarn** writes an "X" and "his mark" next to his. Grace Nail Johnson had a reputation as an excellent hostess; the daughter of real estate magnate **John B. Nail**, her genteel style contrasted sharply with the roaring parties to be found elsewhere in Harlem. At a gathering in 1931 at which Paul Robeson performed readings from Johnson's volume *God's Trombones*, **Ruby Darrow** commented, "Henceforth when the Johnsons invite us to come at 9 p.m., we'll come at *8*!"

After fatigue compelled Johnson to resign his position as Executive Secretary of the N.A.A.C.P., he accepted an appointment on the faculty at Fisk University in Nashville, Tennessee, and the Johnsons sold their apartment at 187 West 135th Street. They continued to host guests at their home in Nashville, as well as their Berkshires cabin "Five Acres" in Great Barrington. One of their regular guests was Great Barrington native W. E. B. Du Bois, who visited Grace Johnson after the funeral of his wife, Nina Gomer Du Bois, writing in 1950, "On the sad but triumphant day when I buried my wife after 55 years of marriage, to an old friend & a beautiful house & shrine."

28

Guest Book from the Manhattan home of James Weldon and Grace Nail Johnson 1923–1931

James Weldon Johnson and Grace Nail Johnson Papers

Guests

NAME	RESIDENCE
Eslanda Goode Robeson	233 W 148 St NYC.
Julius Bledsoe Anderson 698/	80 Edgecombe Ave
The Walter Whites	90 Edgecombe Ave
Fania Marinoff	150 W. 55th
Donald Angus	14 E. 9th
Miguel Covarrubias	11 Charles St.
Percy Hammond	10 W. Tenth street
Dorothy Dudley Harvey	60 W. 12th Street
Susan Grant Smith	32 Washington Sq. Square
Jean Toomer	439 West 23rd St.
Rosa Conkling Boyce	Kelso Farm Hyattsville, Md
Irita Van Doren	47 Charleton St. N.y.
	Tallahassee Florida

ARRIVAL	DEPARTURE	REMARKS
52 nd St Theatre		
Heywood Broun — Schuyler 6306 —		333 W 85th St N.Y.C.
Lawrence Brown	188 W. 135th. St. N.Y.C.	
Dorothy T. Van Doren	43 Barrow Street N.Y.C.	
Temple Duncan Hale	333 West 85 Schuyler 6306	
Mark Van Doren	43 Barrow Street, N.Y.C.	
Crystal Bird — 135 East 52nd Street — New York City		
Roland Hayes	Symphony Hall Boston, Mass.	
J.O. Plummer	125 E. Hargett St Raleigh, N.C.	
A Schomburg	Phone 3900 Rector home 8410 Lafayette. 105 Roosevelt	Brooklyn N.Y.
W.E.B. DuBois	606 St Nicholas Ave., N.Y.C.	
Jessie Fauset	203 West 122 nd St. New York	

Nella Larsen's letters to **Carl Van Vechten** have proven an important resource for biographers, as Larsen has long been viewed as one of the more mysterious figures of the Harlem Renaissance. Larsen met Van Vechten at a party in 1925 and they quickly became close friends; for some time Larsen and her husband **Elmer Imes** were sufficiently close with Van Vechten and his wife **Fania Marinoff** that they could drop in any given evening. Van Vechten encouraged Larsen to write and introduced her to his publisher **Alfred Knopf**.

The resulting novel, *Quicksand*, published in 1928, follows the adventures of Helga Crane, a young woman of mixed black and Danish ancestry who struggles to find a place in both Danish and African American circles. Larsen based Helga's biographical details on her own: she was the daughter of a Danish woman and a black West Indian man. Her parents' relationship failed when she was still an infant. Her mother remarried a fellow Danish man named Peter Larsen, and they had another daughter. The new family struggled to include Nella, and when she reached college age she was dispatched to Fisk University to learn among "her people."

Shy and understandably wary of groups after her experience, Larsen avoided most gatherings in Harlem, though she socialized regularly with **Walter White**, **Dorothy Peterson**, and **James Weldon** and **Grace Nail Johnson**. Historian Allyson Hobbs writes, "Groups spelled trouble for Larsen. She remained an outsider and never truly belonged to any group, and certainly not to one with mostly African American members."[42]

If the author of the novels *Quicksand* and *Passing* (1929) sat out the parties at 267 House and the making of *Fire!!*, Larsen nonetheless made important contributions to the New Negro movement beyond her fiction.

After becoming the first African American to earn a library degree, she took over the children's department at the 135th Street Branch of the New York Public Library. In 1926 she resigned from the library to work on writing, but also suggested to "Carl dear" that she would open a bookstore in Harlem, which she identified as much in need of one. As biographer Thadious Davis surmises, "her disappointment must have been great" when **Douglas Howe** opened the Hobby Horse Bookshop at 205 West 136th Street before she could bring her plans to fruition.[43]

Larsen lost touch with Van Vechten soon after her divorce from Elmer Imes in 1933, communicating with him with decreasing frequency. She struggled to achieve the same creative output that had produced two remarkable novels in two years, and faded out of the literary scene. Easily among the best novels of the period in terms of prose, characterization, and plot, *Quicksand* and *Passing* were both well received in their time. Though they fell out of print, they were reissued in 1986 and have remained in print, popular on college syllabi, ever since.

29

Nella Larsen, Letters to Carl Van Vechten 1925–1934

Carl Van Vechten Papers

Thursday
[19 Mar 1928]

Carl dear;

A week since I had your letter. Down with my old friend, the grip again.

No news in Harlem.

A letter from Gladys enclosing a snap shot of your name sake in the back of which (the picture not the baby) is written "Brother at six month." I surmised that this poor infant has had so many names that now he is simply Brother. When he is about six and starting to school and they are compelled to call him something else, you'll see that it will be Walter.

A popular urban legend or joke from 1920s New York goes as follows:

A porter picks up a woman's luggage at Grand Central Station.
"Good morning, Mrs. Astor," he says.
"How do you know my name, young man?" she asks.
"Why ma'am, I met you last weekend at Carl Van Vechten's."

By no means an uncontroversial contributor to the Harlem Renaissance, **Carl Van Vechten** exerted an influence behind the scenes that often goes uncredited. For introducing **Langston Hughes** to the **Knopfs**, bankrolling the journal *Fire!!*, and authoring the problematic yet best-selling novel *Nigger Heaven* (1926), Van Vechten secured a place in Renaissance history. The parties he threw with his wife, the actress **Fania Marinoff**, were also legendary. In 1924, the couple moved north from East 19th Street to 150 West 55th, and, as biographer Bruce Kellner writes, "The twenties may not have roared there, but they sang lustily enough, usually in a minor key. The parties really came into their own […] when Carl began to publicize the sudden interest in Negro arts and letters, and 150 West Fifty-fifth Street became, as **Walter White** later put it, the midtown branch of the N.A.A.C.P."[44]

Kellner describes the Van Vechtens' décor thus: "a black and orange cubist study, and a sea green and purple and raspberry drawing room." In 1927, they commissioned the artist **Aaron Douglas** to design and paint a mural in their bathroom in proposed purples, blues, and pinks. Van Vechten wrote appreciatively of the work in a diary entry on August 8, 1927.[45] One of Douglas's earliest murals, the design contrasts skyscrapers with the leafy jungle, one of Douglas's favorite motifs, with both backgrounds populated by what art historian Richard Powell calls Douglas's "ubiquitous slit-eyed figures."[46] Douglas would go on to focus more intently on murals, including his great masterpieces in Fisk University's Cravath Library, first painted in 1930 and restored in 2003.

30

Aaron Douglas, Mural design for Carl Van Vechten's bathroom 1927

Carl Van Vechten Papers

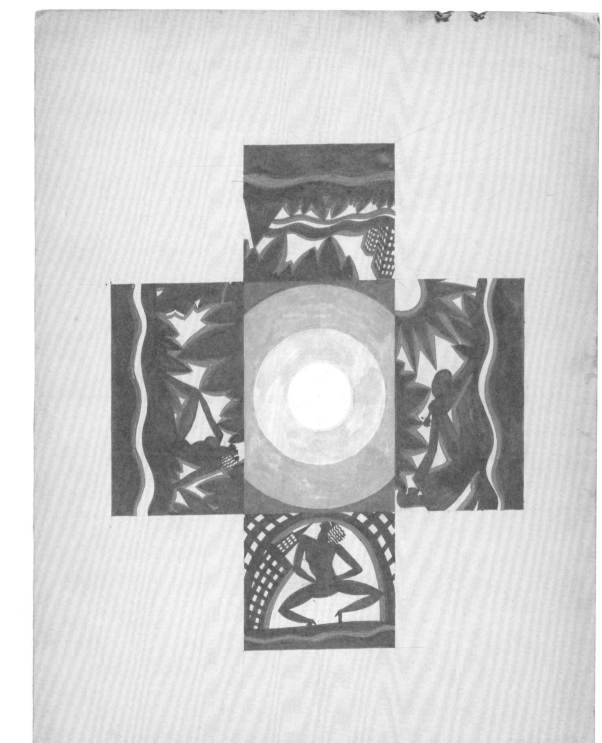

In a note on Department of Labor stationery (where she was Commissioner of Conciliation), **Georgia Douglas Johnson** congratulates **James Weldon Johnson** (they were not related) on the publication of *Black Manhattan*, his 1930 history of African Americans on the island. Georgia writes that she hopes "you will talk to us some time here about it." By "us" and "here," she refers to her home at 1461 S Street NW in Washington, where Johnson regularly hosted the "Saturday Nighters" from 1921 through the 1930s.

Among the several small African American literary salons of the 1920s, including the Black Opals in Philadelphia, the Ink Slingers in Los Angeles, and the Saturday Evening Quill Club in Boston, Johnson's Saturday Nighters was the largest and had the most storied alumni. It counted as regulars at various times **Jean Toomer**, **Langston Hughes**, **Gwendolyn Bennett**, **Jessie Fauset**, and **Rebecca West**. As Elizabeth McHenry writes, "After leaving Washington D.C., and their weekly involvement with the Saturday Nighters, the extended 'family' formed by the group continued to rely on regular contact with and the soothing 'presence' of Georgia Douglas Johnson, even if they did not always like (or could not read) what she had to say."[47]

Born in 1877, Johnson's status as a slightly older member of the Renaissance crowd lent her a maternal cast. Her own poetry typically hewed closely to traditional Victorian forms. Bennett's gossipy "Ebony Flute" column in *Opportunity* reported on the doings of the group, reminding readers that "We who clink our cups over New York fire-places are wont to miss the fact that little knots of literary devotees are in like manner sipping their 'cup o' warmth' in this or that city in the 'provinces.'"[48] Several months later, she recounted an evening at Johnson's home:

The *Saturday Nighters* of Washington D.C. met on June fourth at the home of Mrs. Georgia Douglas Johnson. Mr. **Charles S. Johnson** was the guest of honor. It was particularly pleasing to see and talk with Miss **Angelina Grimké**. She is a beautiful lady with ways as softly fine as her poems. The company as a whole was a charming medley.... **E.C. Williams** with his genial good humor; **Lewis Alexander** with jovial tales of this thing and that as well as a new poem or two which he read; **Marieta Bonner** with her quiet dignity; **Willis Richardson** with talk of 'plays and things'... and here and there a new poet or playwright... and the whole group held together by the dynamic personality of Mrs. Johnson.[49]

Working full-time and sending her two sons to college after her husband's death in 1925, Johnson nonetheless managed to write poetry and plays, including the important anti-lynching play *A Sunday Morning in the South* and her one-act *Plumes*, which took first prize in the *Opportunity* contest in 1927. Between 1935 and 1939, Johnson would submit five plays to the Federal Theatre Project.

31

Georgia Douglas Johnson, Letter to James Weldon Johnson January 3, 1930

Georgia Douglas Johnson Collection

1/3/30.

Dear Mr. Johnson:

I was sorry not to see you at the dinner. Mrs
Johnson told me over the phonelast night when I was in New York
that you had not recieved my letter of thanks ,so I send this one
which is number 2.

I was delighted beyond words with your token
as a Christmas greeting and wish to say that my friends are very
envious of me. They all admire it and it has the place of vantage
on my parlor table.

I do think it is exquisite both as a literary work
and also as a thing of beauty for the eye.

We are all sorry you ar leaving your work as
secretary of the Assiciation as you were so forceful there but we
will be able now to hear from you more at length through your pen.

I am now reading Vlack anhattan and hope you will
talk to us sometime here about it.

With seasonal greetings to you and your charming
wife I am

Very sincerely,

Georgia Douglas Johnson.

By the time the *New York Herald Tribune* declared the Negro Renaissance underway in May 1925, neither **Claude McKay** nor **Langston Hughes** lived in Harlem. After leaving New York in 1922 for Russia, McKay eventually settled in France; Hughes led an itinerant existence after he withdrew from Columbia University in the spring of 1923 until he enrolled at Lincoln University in Pennsylvania in February 1926.

Convivial, frank, and affectionate, Hughes's and McKay's letters to one another fill each other in on doings around Harlem in spite of their mutual absence. They also trade notes about work: in September 1924, writing that he will be unable to visit Hughes in Genoa, where Hughes is stranded and penniless, McKay encloses two copies of *The Crisis* and comments on Hughes's poetry:

"I want to talk to you about your writings. Your stuff seems the most sincere and earnest to me of any that young Afro-America is doing. Of course, [Countée] Cullen is facile and more fluent than you but he lacks depth. [Alain] Locke showed me a few things of yours. You ought to pay more attention to technique I think. That blues thing for instance I thought remarkably good but you should have made the whole of it more colloquial. You bring in some literary words which appear strange in such an atmosphere."

McKay gripes to Hughes about **William Stanley Braithwaite's** criticism and **Alain Locke's** editorial choices (Locke omitted his poem "Mulatto" from the *The New Negro* and softened the title "The White House" to "White Houses"). Indeed, if the Harlem Renaissance is often viewed as resting on a divide between an older and younger generation of writers, McKay, born in 1889 and twelve years Hughes's senior, served as a big brother figure, doling out advice and guidance to the younger yet more celebrated poet. "Don't get mad at my opinion," grumbles the famously grouchy McKay. "It's friendly."

For his part, Hughes is grateful for McKay's letters, sharing news of his poem "The Weary Blues" in 1925 and detailing his plans to tour the South in 1927. He gushes in typical fashion about McKay's first novel, *Home to Harlem* (1928), also the first novel by an African American to reach the bestseller list. By then at Lincoln, Hughes writes that the book "is the most exciting thing in years. Undoubtedly, it is the finest thing 'we've' done yet. And I don't mean limited by the 'we.'" In September of that year, Hughes types a litany of gossip on the whereabouts of all their friends and colleagues:

Did you like **Bud [Rudolph] Fisher's** book? Too much surface, is the verdict of the niggerati. They expected better things of Bud, they say, and the colored papers don't seem to have gotten insulted over it yet. Or maybe you killed all the critics with your brick [i.e., *Home to Harlem*]. **Nella Larsen** is said to have finished another novel [*Passing*]; **Walter White** a book on lynching [*Rope and Faggot: A Biography of Judge Lynch*]; **Eric [Walrond]** his Panama canal volumn [sic]; and **Wallie [Wallace Thurman]** his "The Blacker the Berry" which is due out in January.... Harlem cabarets are disgracefully white. The only way Negroes get in nowadays is to come with white folks, whereas it used to be the other way around.

Though both Hughes and McKay experienced significant shifts in their thinking about politics and poetry over the ensuing decades, they remained friends until McKay's death in 1948.

32

Langston Hughes, Letters to Claude McKay 1925–1943

Claude McKay Collection

Claude McKay, Letters to Langston Hughes 1924–1943

Langston Hughes Papers

Thomas, Cook et Fils
2 Place de la Madeleine
Paris
May 9th 1927

My dear Langston

I was very happy to get this letter of yours. I have had no real news of our country for

I wrote to Walter White and Locke ... ing them small favors - a couple ... to refer to in doing my book. I had ... expressed friendliness towards me ... has deigned to reply. I don't know ... Walter or what. I did give ... down one a poem of mine ... he thought was 'too strong' ... number, but we settled that ... must then suppose (to be fair ... is due to overwork.' ... now I made use of

Dear Claude,
I was mighty glad to get your letter....this is no answer but just a note to enclose this grand ray that I was afraid you didn't send you! Are you getting the clippings from the Negro papers? They're mostly like this one! And Donald Hayes, a young poet, defends you (and me) in this week's Defender, as I see in the Library today. The Bookman reviews your novel & Francis Carco's Perversity in

Already notorious as "267 house" by 1930, the rooming house at 267 West 136th Street became infamous as "Niggeratti Manor" in resident **Wallace Thurman's** 1932 novel *Infants of the Spring*. Named for **Zora Neale Hurston's** portmanteau of "nigger" and "literati" (though always spelled with two t's by Thurman), the Manor hosted many of Harlem's cultural luminaries, including Thurman and **Richard Bruce Nugent**, who both moved in following the publication of *Fire!!*, as well as actor **Service Bell** and artist **Rex Gorleigh**. **Langston Hughes** stayed there on his visits from Lincoln University in 1926-27.

Businesswoman **Iolanthe Sydney** purchased the building with an eye to supporting artists; she charged nominal rents and rarely collected them. The address became as famous for its parties as for the creative production of its residents.

Nugent, called Bruce by friends, would make his name in Harlem as both a visual artist and a writer, publishing under the name Richard Bruce. Before moving to Harlem in 1925, Nugent had been a regular attendee of **Georgia Douglas Johnson's** "Saturday Nighters" salon in Washington, where he had met and befriended Hughes. Openly gay at a time when the metaphor of the closet had not yet been invented, and always unabashedly eager to shock, Nugent contributed a short story to *The New Negro* and illustrations to *The Crisis, Opportunity,* and *Fire!!* as well as Thurman's article "Negro Life in New York's Harlem." He auditioned for the Theatre Guild's production *Porgy* (1927) on a lark and toured with the cast for nearly two years. He appeared onstage for a second time in *Run Little Chillun* (1933). He is perhaps best remembered for the writing he contributed to *Fire!!*, a modernist stream-of-consciousness story titled "Smoke, Lilies, and Jade," which many scholars recognize as the first work of fiction by an African American to feature explicitly gay characters and a gay relationship.

One of the youngest of his cohort, Nugent lived to 81 and proved an invaluable resource for firsthand accounts of the Harlem Renaissance period and of his colleagues, particularly Hughes and Thurman. This photograph of Niggeratti Manor, obtained by Nugent from the New York City Municipal Archives, serves to document the legendary place.

33

Photograph of 267 West 136th Street (a.k.a. "Niggeratti Manor") 1942

Richard Bruce Nugent Papers

Though his interest in African Americans was seen even by **Carl Van Vechten** himself as likely a passing fancy, collecting and documenting African American life and culture turned out to be one of his greatest enduring passions. After he read **Walter White's** novel *Fire in the Flint* in 1924, Van Vechten asked **Alfred Knopf**, his mutual publisher with White, to introduce them. Through White, Van Vechten soon met others, including White's mentor **James Weldon Johnson**, who shared a birthday with Van Vechten. The two would become close friends.

A photography hobbyist his entire life, Van Vechten did not build his own home darkroom—in one of the kitchens of his double apartment on 54th Street—until he began using a Leica in 1932. After that, he would shoot friends and acquaintances at home in front of a variety of patterned backdrops. Printing nearly all his negatives, Van Vechten would create 20,000 photographs between 1932 and his death in 1964, nearly half of which he donated to Yale.

Though he photographed many of his African American friends in the 1930s, Van Vechten decided in 1939 that he would make it his mission to capture "every established or promising African American he could cajole to sit for him. Some refused—actor Sidney Poitier, political activist Louise Thompson Patterson, and novelist Ralph Ellison, for example, perhaps distrustful of a white man who still had a bad reputation as an ofay playboy in Harlem's seedy speakeasies during the Twenties."[50] Still, Van Vechten's list of sitters is impressive, and numbers in the hundreds.

"I love myself when I am laughing," **Zora Neale Hurston** writes to Van Vechten, having received a portrait of her taken outdoors in Chicago in 1934. "And then again when I am looking mean and impressive."[51]

Van Vechten's photographs of Hurston, some of the best-known images of her, along with those of **Langston Hughes**, **James Baldwin**, **Ethel Waters**, and countless others, have become ubiquitous, even appearing on postage stamps.

Biographer Bruce Kellner characterizes Van Vechten's style and helps us to imagine one of his sittings:

> What marks a Van Vechten photograph? First, an intense contrast between light and dark, often startling, often glamorous, especially in his early work where the actual lighting can be as fierce as fire or dark enough to lose his subject in shadows. Then background, almost inevitably a profusion of pattern and color, almost invariably a reflection of the subject. Van Vechten's policy was always "to use as much color as possible in backgrounds instead of as little," and he was talking about both black and white and color photography. As for the subjects themselves, he favored a predilection for the silvery profile, the pensive stare, the gravity of insolence. He did not encourage "posing." No mugging, please, no camping for the camera. Smiles are rare, in part because he often barked, "Stop smiling," and in part because of his own unnerving, embalmed stare at his subject while he waited for the "exact second." He believed in it entirely, although there were happy accidents too.[52]

34

Carl Van Vechten, Portraits of Zora Neale Hurston 1934–1940

Carl Van Vechten Papers

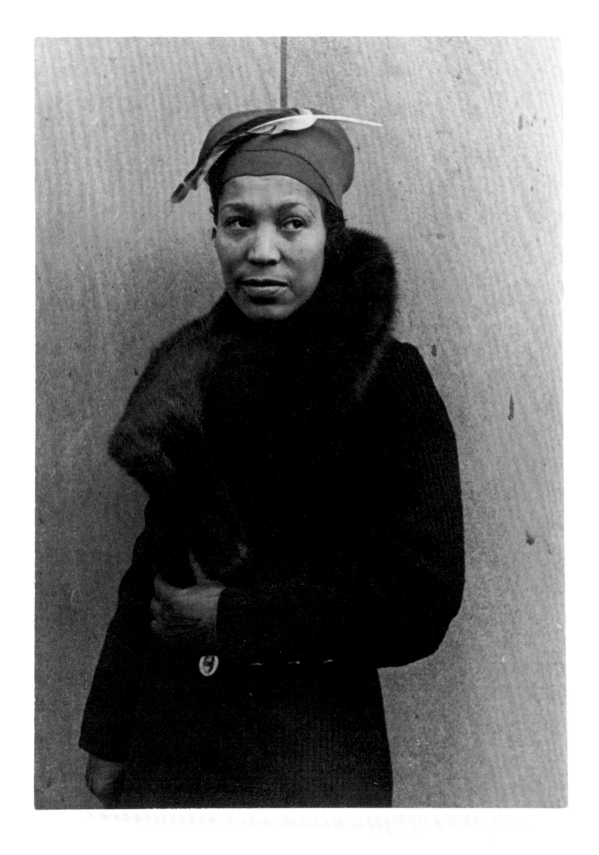

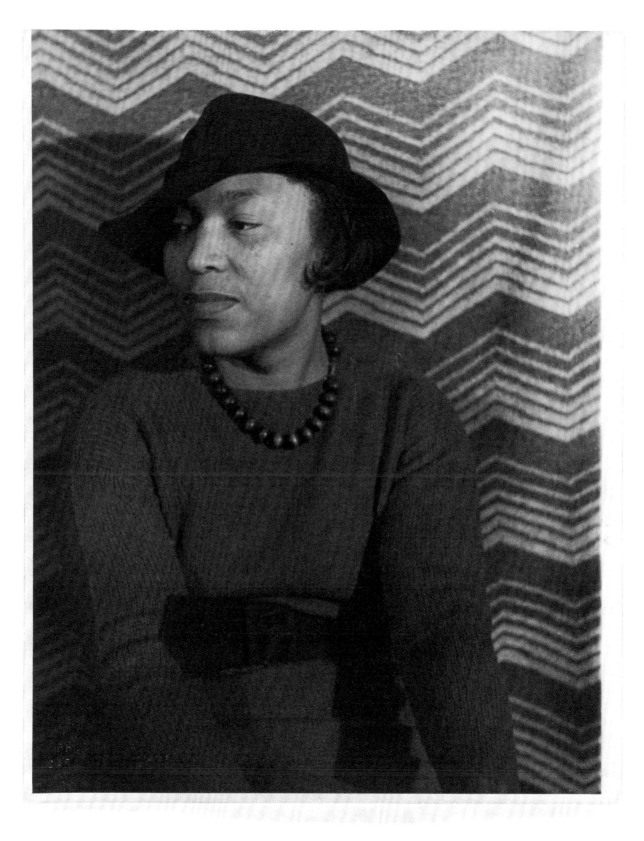

It is this side of prophecy to declare that the undeniable creative genius of the Negro is destined to make a distinctive and valuable contribution to American poetry.

James Weldon Johnson, Preface to *The Book of American Negro Poetry*

The decade from 1924 to 1934 saw an unprecedented output of books by African Americans from mainstream publishers newly amenable to African American writing. **Alfred A. Knopf**, Harper & Brothers, and Boni & Liveright were the primary companies with strong relationships with African American writers. Together with Harcourt, Brace and Macaulay Company, they more than quadrupled the number of African American-authored books published when compared to the preceding decade. These included multiple volumes from **Langston Hughes**, **Jessie Fauset**, **Countée Cullen**, **Nella Larsen**, and **Claude McKay**.

The fervor for African American books led **James Weldon Johnson**, then at work on *God's Trombones*, to offer a novel he had published anonymously in 1912 (to relatively little notice) to Knopf for republication. In the context of the New Negro Movement and with a dust jacket designed by **Aaron Douglas**, *The Autobiography of an Ex-Coloured Man* (with its Anglicized spelling) was reborn as a major African American novel.

At a time when many (including Hughes and McKay) aspired to live by the pen, the publishing environment of the Harlem Renaissance was equally friendly to those in the professions, such as **Rudolph "Bud" Fisher**, a doctor, **Walter White**, and Johnson himself, the latter two both employed by the N.A.A.C.P. Encompassing poetry and short story collections, novels, stories of working class strife and middle class uplift and angst, and satirical science fictions, these books could not be said to share styles, approaches, or even goals. They do, however, all take up the theme of race as it is lived in the United States. Debates raged in publications like *The Crisis* about the best and most appropriate topics for works of African American fiction. The

publication in 1926 of **Carl Van Vechten's** sensational *Nigger Heaven*, which sold out its initial printing of 16,000 copies and went through nine printings in four months on the market, only heightened the controversy. **W. E. B. Du Bois** called Van Vechten's novel "a blow in the face" and "an affront to the hospitality of black folk and the intelligence of white."[53] Still, these works, including Van Vechten's, were seen by many as providing a window into life in Harlem for those outside, and as celebrating the lives of its inhabitants as worthy of story.

McKay's first novel, *Home to Harlem*, stoked Du Bois's ire. Du Bois contrasted the novel, the story of carefree, itinerant Jake, his educated (and therefore more troubled) friend Ray, and their adventures in Harlem's rent parties and cabarets, with Larsen's more refined *Quicksand*, writing: "After the dirtier parts of its filth I feel distinctly like taking a bath."[54] Despite (or perhaps thanks to) Du Bois's criticism, the novel flew from the shelves. Some 75,000 copies were printed, and it was the first novel by a black person to appear on the *New York Times* bestseller list.

The onset of the Depression took its toll on book publishing as a whole and the aspirations of African American writers in particular. Still, one of the Renaissance's best remembered novelists had hardly entered the game: though she published short works throughout the 1920s, **Zora Neale Hurston's** first book, *Jonah's Gourd Vine*, would not arrive until 1934, with her most celebrated, *Their Eyes Were Watching God*, published by Lippincott in 1937. By then, the paths to publishing cleared by the New Negro generation would be open to a succeeding generation of writers, including Richard Wright, Ann Petry, Gwendolyn Brooks, and others.

35

A Collection of First Editions (with one second edition)
Walter White, *The Fire in the Flint*, Alfred A. Knopf, 1924
Jessie Redmon Fauset, *There Is Confusion*, Boni & Liveright, 1924
Countée Cullen, *Color*, Harper & Brothers, 1925
Langston Hughes, *The Weary Blues*, Alfred A. Knopf, 1926
Eric Walrond, *Tropic Death*, Boni & Liveright, 1926
James Weldon Johnson, *The Autobiography of an Ex-Coloured Man*, Alfred A. Knopf, 1927
Nella Larsen, *Quicksand*, Alfred A. Knopf, 1928
Claude McKay, *Home to Harlem*, Harper & Brothers, 1928
Rudolph Fisher, *The Walls of Jericho*, Alfred A. Knopf, 1928
Wallace Thurman, *The Blacker the Berry*, The Macaulay Company, 1929
Arna Bontemps, *God Sends Sunday,* Harcourt, Brace and Company, 1931
George Schuyler, *Black No More*, The Macaulay Company, 1931

James Weldon Johnson Memorial Collection

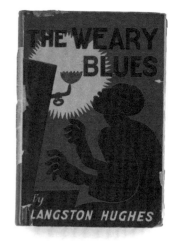

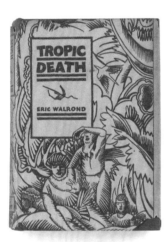

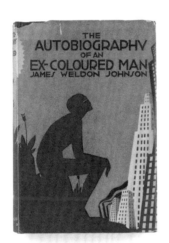

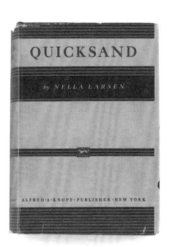

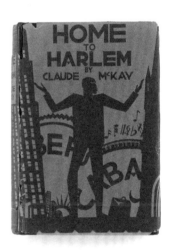

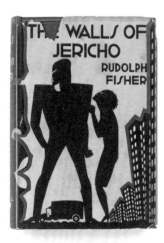

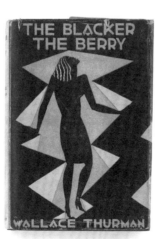

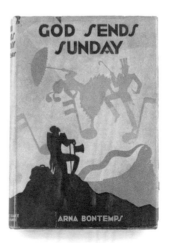

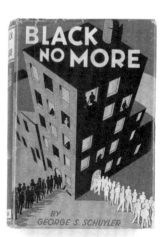

The forerunner of the Harlem Renaissance's explosion of prizes for African Americans was the Spingarn Medal, created by N.A.A.C.P. chairman **Joel Elias Spingarn** in 1915 to be awarded for "the highest and noblest achievement of an American Negro during the preceding year or years." A splendid fourteen karat gold medallion featuring Lady Justice standing before a rising sun and the words "FOR MERIT," the Spingarn Medal embodied the N.A.A.C.P.'s belief that individual achievements could prove the race worthy of equal treatment. As Bruce Kellner observes, "Ruthlessly and single-mindedly integrationist all his life, Joel Spingarn believed implicitly in **W. E. B. Du Bois's** theory of the 'talented tenth.'"[55] The "talented tenth" thesis, introduced in 1904, argued that the race as a whole could be pulled up by the achievements of its most talented people. The rhetoric of the N.A.A.C.P., including the "advancement" in its name, embraced this meritocratic mission.

Spingarn and N.A.A.C.P. Executive Secretary **James Weldon Johnson** admired one another and found each other to be kindred spirits. The son of an Austrian Jewish immigrant who had made a fortune as a tobacco merchant, Spingarn had moved on from a career as a leading literary scholar to help co-found the N.A.A.C.P. It should come as little surprise that nearly half the Spingarn Medals awarded in its first sixteen years—from 1915 to 1931—were to people involved in creative fields. These included composer **Harry T. Burleigh**, literary critic **William Stanley Braithwaite**, W. E. B. Du Bois, actors **Charles S. Gilpin** and **Richard B. Harrison**, concert tenor **Roland Hayes**, and novelist **Charles Chesnutt** (as something of a lifetime achievement award in 1928).

Johnson, awarded the Spingarn Medal in 1925 with the citation "author, diplomat, and public servant," had by then long been established as a man of many talents, from writing popular song lyrics to diplomacy, and was considered a leader of the fledgling New Negro Renaissance. Johnson's major achievements in the years leading to the award included his advocacy for the unfortunately doomed Dyer congressional anti-lynching bill and the publication of *The Book of American Negro Poetry* in 1922; 1925 would see *The Book of American Negro Spirituals*, co-edited with his brother **J. Rosamond Johnson**. Though most news reports of Johnson's award cited his long and distinguished career to date, some critics suggested that the N.A.A.C.P. should not award the medal to someone so high within their own organization. The Spingarn Medal continues to be awarded today.

36

Spingarn Medal awarded to James Weldon Johnson 1925

James Weldon Johnson and Grace Nail Johnson Papers

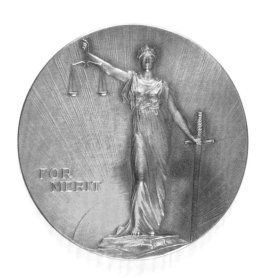 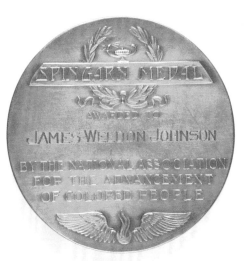

While some poets of the Harlem Renaissance, including **Claude McKay** and **Countée Cullen**, adapted African American themes to traditional English poetic forms such as the sonnet, villanelle, elegy, and ode, others, like **Langston Hughes** and **Sterling Brown**, sought to blend African American vernacular rhythms with traditional lyric poetry. Though we might contrast these differing approaches as an aesthetic "debate," this was conducted less among artists than between artists and critics. McKay always wrote admiringly to Hughes of the latter's work, and Cullen performed Hughes's poetry aloud at the 135th Street Library.

A lifelong lover of music, Hughes was captivated by the way an emergent African American musical form known as the blues blended hope and bitterness, tragedy and humor. He would later call this ironic form "laughing to keep from crying." The repetition of the first line in the traditional twelve-bar blues lyric, with the form AAB, usually sung with the same melody, but over a different chord, was suggestive to Hughes of the multiple valences in which a situation could be interpreted. His "Listen Here Blues" exemplifies the repetition and turn of an AAB stanza:

> Sweet girls, sweet girls,
> Listen here to me.
> All you sweet girls,
> Listen here to me:
> Gin an' whiskey
> Kin make you lose yo' 'ginity.[56]

The ability of the form to wail, to celebrate, to cope, and to criticize seemed to Hughes perfectly suited to the situation of African Americans in the United States.

After the success of *The Weary Blues*, published by Alfred A. Knopf in January 1926 with the help of **Carl Van Vechten**, Hughes handed a manuscript of sixteen blues poems to Van Vechten in October. It already bore the title "Fine Clothes to De Jew," though biographer Arnold Rampersad suggests that the title may have been Van Vechten's idea, rather than Hughes's. Hughes would later regret using the line, a reference to the common practice of pawning "Sunday best" clothing to make it through the week.

Van Vechten set about placing some of the poems in publications, such as the Chicago *Tribune*, the *New Republic*, and *Vanity Fair*, noting his progress on Hughes's table of contents. In his first draft, Hughes had made a series of dedications to Harlem's blues pantheon: "Hard Luck Blues" for **Paul Robeson**, "Gypsy Man" for **Bessie Smith**, and "Lament over Love" for **Clara Smith**. The volume as a whole was dedicated to Van Vechten. By the time it was published, all but the Van Vechten dedication had disappeared.

In 1927, *Fine Clothes to the Jew* was published by Knopf, with a dust jacket designed by **Aaron Douglas**. Rampersad calls *Fine Clothes to the Jew* Hughes's "most brilliant book of poems […] comparable in the black world to *Leaves of Grass* in the white."[57] But contemporary critics were appalled at Hughes's celebration of what they saw as an underworld of sexual licentiousness and immorality. A reviewer for *The New York Amsterdam News* called Hughes a "sewer dweller" and the volume "100 pages of trash." The *Chicago Whip* said "These poems are unsanitary, insipid and repulsing," dubbing Hughes the "poet low-rate" of Harlem.[58]

37

Langston Hughes,
Manuscript of *Fine Clothes to the Jew: Sixteen Blues Poems*
1927

Langston Hughes Papers

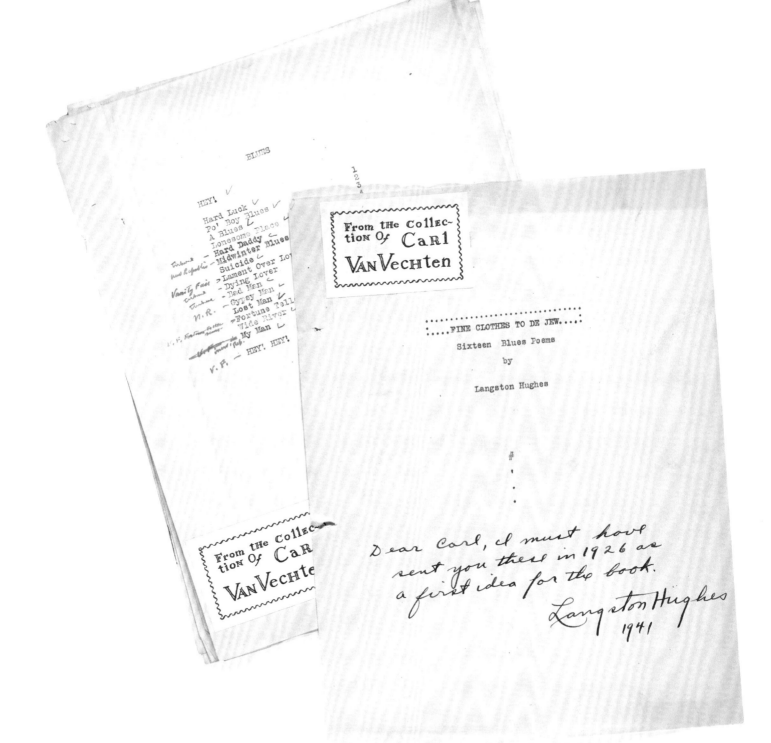

BLUES

HEY!

 Hard Luck
 Po' Boy Blues
 A Blues
 Lonesome Place
Fortune — **Hard Daddy**
New Republic — Midwinter Blues
 Suicide
Vanity Fair — Lament Over Love
Fortune — Dying Lover
 Bad Man
 Gypsy Man
 N.R. — Lost Man
V.F. Fortune teller — Fortune Teller
 Wide River
 My Man
V.F. — HEY! HEY!

1
2
3
4

......FINE CLOTHES TO DE JEW.....

Sixteen Blues Poems

by

Langston Hughes

#

*Dear Carl, I must have
sent you these in 1926 as
a first idea for the book.*

Langston Hughes
1941

Insofar as the Harlem Renaissance can be thought to have been created by design, the writing contest served as cornerstone. "These contributions demand incentives," as *Opportunity* editor **Charles S. Johnson** put it in September 1924:

> To stimulate and encourage creative literary effort among Negroes; to locate and orient Negro writers of ability; to stimulate and encourage interest in the serious development of a body of literature about Negro life, drawing deeply upon these tremendously rich resources; to encourage the reading of literature both by Negro authors and about Negro life, not merely because they are Negro authors but because what they write is literature and because the literature is interesting.[59]

Johnson's announcement superseded a similar one to be made by *The Crisis*, as **Joel and Amy Spingarn** had donated $300 for the creation of a prize by that magazine.[60] The *Opportunity* prizes would also overshadow those of *The Crisis* in the glamour of their dinners. In May 1925 at the Fifth Avenue Restaurant, over 300 guests watched as **James Weldon Johnson** read aloud the piece that won the first prize for poetry, **Langston Hughes's** "Weary Blues." **Countée Cullen** took second prize for poetry, and Hughes and Cullen split the third prize. Other prizewinners have faded into obscurity, but some would rise to the pantheon of African American writing, including **Sterling Brown**, **E. Franklin Frazier**, **Zora Neale Hurston**, and **Eric Walrond**. The great majority of contest judges were established white writers, and included **Carl Van Doren**, **Zona Gale**, **Fannie Hurst**, **Dorothy Canfield Fisher**, **Eugene O'Neill**, **Witter Bynner**, and **Clement Wood**.

To measure the importance of the prize contests in the lives of these writers, one need only read **Gwendolyn Bennett's** letters to **Harold Jackman**, which register her delight at the November 1925 *Crisis* awards, and her aspirations for the 1926 contests (she entered twelve pieces in the 1926 *Opportunity* contest). Not everyone enjoyed the prize culture, however. In 1924, upon discovering that **Alain Locke** would edit a special issue of *Survey Graphic*, satirist **George S. Schuyler** awarded him his "monthly elegantly embossed and beautifully lacquered dill pickle."[61] Schuyler would also imply that his "cut-glass thunder-mug" was financed by "business man" **Casper Holstein** (who also funded the *Opportunity* prizes).

In January 1926, no doubt inspired by the enthusiasm surrounding the magazine prize contests, **Albert and Charles Boni** announced a staggering $1000 prize for the best novel by an author "of Negro descent." The prize required: "the novel must deal with Negro life in the sense that one or more of its leading characters must be of Negro descent and its action must show the influence of this fact." The Boni brothers' still-new publishing venture had just issued Locke's anthology *The New Negro*. Long associated with Greenwich Village progressivism, Albert Boni and **Horace Liveright** had been the first American publisher of William Faulkner and Ernest Hemingway. In 1923, they published **Jean Toomer's** *Cane*. The Boni Prize contest, like the other contests, assembled a distinguished panel of judges. For reasons that remain unclear, the prize was never awarded.

38

Advertisement for Albert & Charles Boni, Inc. "Negro Life Novel" Contest
1926

James Weldon Johnson and Grace Nail Johnson Papers

ALBERT & CHARLES BONI
INC.

OFFER A PRIZE OF $1000 FOR THE BEST NOVEL OF NEGRO LIFE WRITTEN BY A MAN OR WOMAN OF NEGRO DESCENT.

JUDGES:

Henry Seidel Canby

W. E. B. Du Bois

Charles S. Johnson

James Weldon Johnson †

Edna Kenton

Laurence Stallings

Irita Van Doren

Writing in 1950, the poet Margaret Walker attempted to distinguish poets of her generation from those of the New Negro Renaissance. Walker landed on "socioeconomic and political factors" as the driving difference, noting that the Wall Street crash of 1929 and the subsequent Depression had ended "the halcyon days of individual patronage of the arts" and given way to federal funding in the form of the Works Progress Administration and philanthropic organizations like the Guggenheim Foundation and the Rosenwald Fund.[62]

Though numerous "angels" supported artists in Harlem (they were dubbed "Negrotarians" in **Zora Neale Hurston's** clever coinage), only one insisted that her charges call her "Godmother." Described only with this pseudonym in Hurston's 1942 autobiography *Dust Tracks on a Road*, and only as a "Park Avenue Patron" in **Langston Hughes's** 1940 *Big Sea*, **Charlotte Louise Vandervere Quick Osgood Mason** would have been known to Walker in 1950 by reputation, if not by name.

Today Mason serves as a symbol of how problematic white patronage could be for African American writers: insistent on "primitive" portrayals, capricious and eccentric, she referred to **Langston Hughes** in letters as "boy." Mason's protégées, who included Hurston and Hughes as well as **Alain Locke**, **Miguel Covarrubias**, and **Aaron Douglas**, were constantly aware of the compromised conditions under which they enjoyed her support.

Widowed in 1905, Charlotte Mason had by 1926 become attracted to the cause of African American artists. She would ultimately give over $75,000 to African Americans (equivalent to more than one million dollars today).[63] She met Hughes through Locke in 1927, just as Hughes was beginning his studies at Lincoln University. What followed among Godmother, Locke, and Hurston achieved levels of intrigue and sabotage worthy of a telenovela.

By the fall of 1927 Hughes and Godmother reached an agreement: Hughes would receive a stipend of $150 a month, designed to alleviate his financial cares (they would cover his expenses at Lincoln four times over) so that he could write his first novel. Unlike Hurston, who received $200 a month but also relinquished the folklore she would collect to Mason, Hughes retained ownership of his writing.

Throughout their ultimately fraught relationship, Godmother inundated Hughes with gifts, enabling him to live "a life as close to luxury as he would ever come."[64] These included evening wear (so that he could escort Godmother to performances), a leather bag, and his first piece of African art. Though their break in 1931—orchestrated by Hurston and Locke—was a devastating loss for Hughes, he would, throughout his life, describe Mason as a mentor of sorts, writing in *The Big Sea*, "I found her instantly one of the most delightful women I had ever met, witty and charming, kind and sympathetic, very old and white-haired, but amazingly modern in her ideas, in her knowledge of books and the theater, of Harlem, and of everything then taking place in the world."[65]

39

Charlotte Osgood Mason (a.k.a. "Godmother") Gift Tags for Langston Hughes 1927–1931

Langston Hughes Papers

For when you go a-vagabonding

Your Indian Ancestor.

From us Barclays Mews

MERRY CHRISTMAS
LARRY YORK
NEW BAG.
3187
MERRY CHRISTMAS

CHRISTMAS GREETINGS

MERRY CHRISTMAS
I have known you

Langston it is high time you had a piece of African Art!

(1927)
Godmother's cards [+ misc. gift tags]

With a title alluding to lines from *Hamlet* ("The canker galls the infants of the spring / Too often before their buttons be disclosed"), **Wallace Thurman's** 1932 *roman à clef* presages later assessments that the budding Renaissance was "almost 'so-called' from the time it began."[66] *Infants* skewered the efforts of the "younger generation" of which Thurman himself was an avowed member and sometime leader. Following on years of failed projects, including the short-lived "infant" journals *Fire!!* and *Harlem: A Forum of Negro Life*, Thurman's novel of his own time resounded with his disenchantment. The protagonist Ray, a stand-in for Thurman, lives at "Niggeratti Manor," a rooming house very much modeled on 267 West 136th Street, with the irrepressible Paul Arbian (R-B-N for **Richard Bruce Nugent**).

With a sprawling cast that includes cameos by Sweetie Mae Carr (**Zora Neale Hurston**), Tony Crews (**Langston Hughes**), DeWitt Clinton (**Countée Cullen**), his trusty sidekick David Holloway (**Harold Jackman**), Carl Denny (**Aaron Douglas**), Cedrick Williams (**Eric Walrond**), Manfred Trout (**Rudolph Fisher**), Amy Douglas (**A'Lelia Walker Robinson**), and "clucking" Howard University sage Dr. A. L. Parkes (**Alain Leroy Locke**), the novel satirizes the Negro vogue. As Ray observes at one of Niggeratti Manor's heady parties, "Color lines had been completely eradicated. Whites and blacks clung passionately together as if trying to effect a permanent merger. Liquor, jazz music, and close physical contact had achieved what decades of propaganda had advocated with little success. […] This, he kept repeating to himself, is the Negro renaissance, and this is about all the whole damn thing is going to amount to." A literary salon devolves into "pandemonium" and name-calling. Niggeratti Manor is disbanded: landlady Euphoria, accusing its inhabitants of turning it into a "miscegenated bawdy house," offers its rooms to young Negro working girls instead.

Though not the only satire of the period, *Infants* helped shape future criticism of the Harlem Renaissance as more artifice than impact. This is owed in part to the tragic notoriety of its author: Believed by many of his contemporaries to be the unsung, unrealized genius of his generation, Thurman died of tuberculosis and alcoholism in 1934 at the age of 32, the first great literary casualty of the era and a sign of the Renaissance's decline.

40

Wallace Thurman, *Infants of the Spring*
First Edition, The Macaulay Company
1932

James Weldon Johnson Memorial Collection

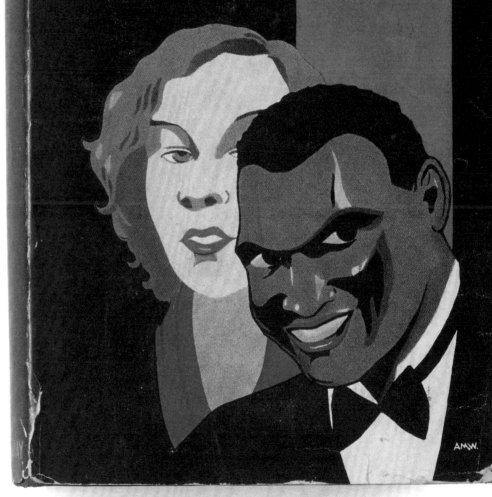

INFANTS OF THE
SPRING

By WALLACE THURMAN

Author of THE BLACKER THE BERRY

AMW.

I picked up glints and gleams out of what I heard and stored it away to turn to my own uses.

Zora Neale Hurston, *Dust Tracks on a Road*

Survey Graphic was the perfect magazine to carry a special issue on the Negro in 1925. Launched in 1921 as a supplement to *Survey*, a social-minded philanthropic journal, the *Survey Graphic* numbers had focused on social issues, especially cultural nationalist movements. Previous issues had already showcased Ireland post-independence, Russia five years after the Bolshevik Revolution, and Mexico.

Once offered the special issue by **Paul Kellogg**, **Charles S. Johnson** tapped Howard University professor **Alain Locke** to compile and edit the material. Kellogg also recommended Bavaria-born portrait artist **Winold Reiss**, who had done the Mexico issue the previous year, to provide artwork.

Locke, who taught English and philosophy at Howard University, but had not yet published much writing of his own, nevertheless made a strong choice for editorship of the volume, if only for his connections alone. He knew **W. E. B. Du Bois** and **James Weldon Johnson**, and already called **Countée Cullen** and **Langston Hughes**, both twenty years his junior, friends. Nevertheless, Locke was less politically engaged than many other candidates, and both the special issue and *The New Negro*, an expanded book version, would draw criticism for ignoring economic and social conditions. For Locke, self-expression and self-determination were apposite; in his introductory essay, he compared Harlem's cultural vanguard to that of Dublin for Ireland or Prague for the "New Czechoslovakia."

Locke and Kellogg contorted behind the scenes to satisfy numerous constituents in the making of the Harlem number. Kellogg wrote to Locke that he had to "'stave off' advance criticism from 'the philanthropic-economic-education group who thought we were neglecting them' on the one hand, 'and on the other a suggestion from an opposite quarter that we go into lynchings.'"[67] Meanwhile, the N.A.A.C.P. counterintuitively advocated against publishing any critiques of living conditions in Harlem, for fear that such negative reports would be used to discourage migration from the South. James Weldon Johnson was appalled at the appearance of Winthrop Lane's "Ambushed in the City: The Grim Side of Harlem," an article that would be omitted from *The New Negro*.[68]

When "Harlem: Mecca of the New Negro" hit stands in March 1925, with Reiss's portrait of tenor **Roland Hayes** gracing the cover (the portrait was repeated opposite the opening article), it sold 42,000 copies—more than twice *Survey's* regular circulation. Contributions from seasoned luminaries Du Bois, Weldon Johnson, **Kelly Miller** of Howard University, anthropologist **Melville Herskovits**, and art collector **Albert Barnes** were accompanied by poetry from Hughes, Cullen, **Claude McKay**, and **Anne Spencer**, and a short story by **Rudolph Fisher**. Though few women were listed in the table of contents, **Elise Johnson McDougald's** essay "The Struggle of Negro Women for Sex and Race Emancipation" took the world to task for its treatment of the African American woman, "struck in the face daily by contempt from the world about her." In spite of Locke and Kellogg's best efforts, not all readers were pleased. Reiss's portraits of "Harlem types" were particularly the subject of rigorous debate. While some praised their verisimilitude, others found them crude and insulting, an unfavorable reflection of the race. Like many Harlem Renaissance legends, the Harlem number of *Survey Graphic* stands as a collection that implies more unity and momentum than it actually delivered.

41

Survey Graphic, Harlem number March 1925

James Weldon Johnson Memorial Collection

Drawn by
Winold Reiss

ROLAND HAYES

Whose achievement as a singer symbolizes the promise of the younger generation

SURVEY GRAPHIC

MARCH
1925

Volume VI
No. 6

Harlem

IF we were to offer a symbol of what Harlem has come to mean in the short span of twenty years it would be another statue of liberty on the landward side of New York. It stands for a folk-movement which in human significance can be compared only with the pushing back of the western frontier in the first half of the last century, or the waves of immigration which have swept in from overseas in the last half. Numerically far smaller than either of these movements, the volume of migration is such none the less that Harlem has become the greatest Negro community the world has known—without counterpart in the South or in Africa. But beyond this, Harlem represents the Negro's latest thrust towards Democracy.

The special significance that today stamps it as the sign and center of the renaissance of a people lies, however, layers deep under the Harlem that many know but few have begun to understand. Physically Harlem is little more than a note of sharper color in the kaleidoscope of New York. The metropolis pays little heed to the shifting crystallizations of its own heterogeneous millions. Never having experienced permanence, it has watched, without emotion or even curiosity, Irish, Jew, Italian, Negro, a score of other races drift in and out of the same colorless tenements.

So Harlem has come into being and grasped its destiny with little heed from New York. And to the herded thousands who shoot beneath it twice a day on the subway, or the comparatively few whose daily travel takes them within sight of its fringes or down its main arteries, it is a black belt and nothing more. The pattern of delicatessen store and cigar shop and restaurant and undertaker's shop which repeats itself a thousand times on each of New York's long avenues is unbroken through Harlem. Its apartments, churches and storefronts antedated the Negroes and, for all New York knows, may outlast them there. For most of New York, Harlem is merely a rough rectangle of commonplace city blocks, lying between and to east and west of Lenox and Seventh Avenues, stretching nearly a mile north and south—and unaccountably full of Negroes.

Another Harlem is savored by the few—a Harlem of racy music and racier dancing, of cabarets famous or notorious according to their kind, of amusement in which abandon and sophistication are cheek by jowl—a Harlem which draws the connoisseur in diversion as well as the undiscriminating sightseer. This Harlem is the fertile source of the "shufflin'" and "rollin'" and "runnin' wild" revues that establish themselves season after season in "downtown" theaters. It is part of the exotic fringe of the metropolis.

Beneath this lies again the Harlem of the newspapers—a Harlem of monster parades and political flummery, a Harlem swept by revolutionary oratory or draped about the mysterious figures of Negro "millionaires," a Harlem preoccupied with naive adjustments to a white world—a Harlem, in short, grotesque with the distortions of journalism.

YET in final analysis, Harlem is neither slum, ghetto, resort or colony, though it is in part all of them. It is—or promises at least to be—a race capital. Europe seething in a dozen centers with emergent nationalities, Palestine full of a renascent Judaism—these are no more alive with the spirit of a racial awakening than Harlem; culturally and spiritually it focuses a people. Negro life is not only founding new centers, but finding a new soul. The tide of Negro migration, northward and city-ward, is not to be fully explained as a blind flood started by the demands of war industry coupled with the shutting off of foreign migration, or by the pressure of poor crops coupled with increased social terrorism in certain sections of the South and Southwest. Neither labor demand, the boll-weevil nor the Ku Klux Klan is a basic factor, however contributory any or all of them may have been. The wash and rush of this human tide on the beach line of the northern city centers is to be explained primarily in terms of a new vision of opportunity, of social and economic freedom, of a spirit to seize, even in the face of an extortionate and heavy toll, a chance for the improvement of conditions. With each successive wave of it, the movement of the Negro

The most enduring collection of the Harlem Renaissance, called by some critics its "Bible," *The New Negro* might be mistaken as representative of the period as a whole, when in fact as a volume it glosses over many important features and figures of its time. Publisher **Albert Boni** proposed issuing the special number of *Survey Graphic* as a print volume early in 1925, two months before the special issue was published. Boni had in mind that the volume would be particularly useful as a school text, and he hoped that "practically all the colleges and universities would buy" it.[69]

Boni's enthusiasm for the Negro vogue had been established with his publication, with partner **Horace Liveright**, of **Jean Toomer's** *Cane* (1923) and **Jessie Fauset's** *There is Confusion* (1924). Shortly after *The New Negro*, Albert and **Charles Boni** would announce a $1000 prize for the best novel of "Negro life."

Illustrated throughout with **Winold Reiss's** portraits and decorations, including hot pink, jungle-themed endpapers, *The New Negro: An Interpretation* also debuted the work of **Aaron Douglas**, newly recruited from Kansas and apprenticed to Reiss. Locke's anthology doubled the original content of "Harlem: Mecca of the New Negro": it ran over 450 pages and was priced like a school text at $5 (over $60 in 2017). The volume's thirty-four African American contributors (along with four white writers) included nearly all the noted members of the literary scene, but with telling exceptions. **Carter Woodson**, founder of African American history as a discipline, was not invited to contribute. *The New Negro* makes no mention of **Marcus Garvey**, jailed by the time of its publication. **A. Philip Randolph**, founder of the Brotherhood of Sleeping Car Porters, was excluded, as were his fellow editors of the leftist journal *The Messenger*, **Chandler Owen** and **George Schuyler** (who had long been Locke's antagonist).

The table of contents is divided into two main sections: "The Negro Renaissance" includes poetry, short stories, drama, and commentary on literature and music. The essays in "The New Negro in a New World" are sociological, but qualitatively so. **W. E. B. Du Bois** is given the last word with his essay "The Negro Mind Reaches Out." Finally, the volume concludes with a bibliography compiled by **Arthur A. Schomburg**, whose unparalleled book collection would in 1926 form the nucleus of the New York Public Library institution named for him. The optimism of the volume is palpable. As Arnold Rampersad writes, "*The New Negro* exudes more than energy—it exudes a quality suspiciously like joy […] The energy and joy in *The New Negro* have political purposes; they are subversive, and thus come tinged with a quality not unlike a thrilling psychological neuroticism, which serves to authenticate the modernist identity of the New Negro."[70] For all its elisions, *The New Negro* rightly stands as a landmark in the history of African American literature. As the poet Robert Hayden would later surmise: "It affirms the values of the Negro heritage and expresses hope for the future of the race in this country, stressing the black man's 'Americanism.'"[71]

42

Alain Locke, Editor, *The New Negro*
First Edition, Albert & Charles Boni, Inc.
1925

James Weldon Johnson Memorial Collection

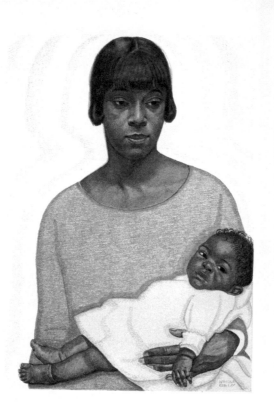

The Brown Madonna

THE NEW NEGRO
AN INTERPRETATION

EDITED BY ALAIN LOCKE

BOOK
DECORATION
AND
PORTRAITS
BY
WINOLD
REISS

ALBERT AND CHARLES BONI
NEW YORK 1925

With the publication of the special Harlem number of *Survey Graphic* in March 1925, **Winold Reiss** was invited to exhibit his portraits of African Americans at the 135th Street Branch of the New York Public Library. Reiss's portraits had provoked a mixed reception, particularly a work titled *Two Public School Teachers*, which showed the two women looking listless (or perhaps tired), one with her hair ever so slightly unkempt (though both their Phi Beta Kappa keys dangled prominently from their necks). **Elise McDougald**, one of the contributors to the issue, wrote to **Alain Locke** that a "furore" had erupted at a forum where **Paul Kellogg** spoke. One man declared, "Should he meet those two school teachers in the street, he would be afraid of them." One of the selfsame teachers, also in the audience, "stood to express her regret that she would frighten him but claimed the portrait as 'a pretty good likeness.'"[72]

Locke rose to Reiss's defense, writing an article titled "To Certain of our Philistines." In his biography of Reiss in *The New Negro,* Locke argued that Reiss struck a perfect balance between individual and type: "He is a folk-lorist of the brush and palette, seeking always the folk character back of the individual, the psychology behind the physiognomy. In design also he looks not merely for decorative elements, but for the pattern of the culture from which it sprang."[73]

Reiss's portraits of **Countée Cullen**, **Langston Hughes**, **Charles S. Johnson**, **W. E. B. Du Bois**, Locke, and **Harold Jackman** (titled *A College Lad*) have become familiar since that time, often as one of only a few artistic portraits of these formidable figures. The exhibition at the library was better received than the portraits in *The New Negro*, perhaps because, in the context of 135th Street, the portraits were free of the pressure to show a positive face on behalf of all African Americans.

Langston Hughes attended the exhibition with Countée Cullen on one of his trips to New York, as he notes on the checklist he saved.

The 135th Street Library was a hub for cultural activity during the Harlem Renaissance (and has been ever since). Led by librarians **Ernestine Rose** and **Regina Anderson**, with **Nella Larsen** joining as children's librarian in 1925, the library hosted frequent readings, lectures, parties, and dramatic performances. In 1926, the Carnegie Corporation gave the New York Public Library funds to purchase the collection of Afro-Puerto-Rican bibliophile **Arthur Alfonso Schomburg**. The Division of Negro History and Prints, which had opened a year earlier, acquired Schomburg's 5,000 books, 3,000 manuscripts, 2,000 visual works, and over 1,000 pamphlets, forming the nucleus for a collection that would engender decades of African American cultural research. Schomburg served as curator until his death in 1938, after which the division was renamed in his honor.

43

Winold Reiss, Checklist for "Exhibition of Recent Portraits of Representative Negroes" at the 135th Street Library 1925

Langston Hughes Papers

EXHIBITION
OF
RECENT PORTRAITS
OF
REPRESENTATIVE
NEGROS^E
BY
WINOLD REISS

AT THE 135th STREET
LIBRARY HARLEM
BEGINNING MARCH 15th

Though **Alain Locke** dedicated *The New Negro* to "the younger generation," the writers and artists who identified themselves with that generation soon decided to speak for themselves. *Fire!! A Quarterly Devoted to the Younger Negro Artists* published its first and only issue in November 1926, a year later. Edited by **Wallace Thurman**, its board included **Langston Hughes**, **Gwendolyn Bennett**, **Richard Bruce Nugent**, **Zora Neale Hurston**, **Aaron Douglas**, and **John Davis**.

An unsigned foreword to the issue, written by Hughes, used the poetic device of anaphora to elaborate on the journal's name. Describing fire as *"burning wooden opposition with a cackling chuckle of contempt,"* it concluded:

FIRE…*weaving vivid, hot designs upon an ebon bordered loom and satisfying pagan thirst for beauty unadorned…the flesh is sweet and real…the soul an inward flush of fire…Beauty?…flesh on fire—on fire in the furnace of life blazing….*
"Fy-ah,
Fy-ah, Lawd,
Fy-ah gonna burn ma soul!"

With its references to "wooden opposition" and "beauty unadorned," *Fire!!* declared that its artists would prize aesthetic values (as they judged them) above all other considerations. Unlike the editors of *Opportunity* and *Crisis*, *Fire!!* artists saw beauty in flesh and would not shy away from the sensual or indecorous. *Fire!!* was inspired in part by the overwhelming negative response to **Carl Van Vechten's** novel *Nigger Heaven*, and it rejected the mandate that the race be portrayed entirely or only in a positive light.

Underwritten by Van Vechten and another half-dozen sponsors and priced at one dollar per copy (*Opportunity* and *The Crisis* both sold for fifteen cents), *Fire!!* didn't spread very quickly. However, it stands as a monumental collection of the younger generation that assembled it. Thurman's short story "Cordelia the Crude," about a young prostitute, became the basis for his Broadway play *Harlem*. Nugent's "Smoke, Lilies, and Jade" stunned readers with its frank depiction of homosexuality. Hurston contributed her play "Color Struck" and the story "Sweat." Bennett's story "Wedding Day," based on her time in Paris the previous year, portrayed an ex-patriate named Paul Watson who finds he can't escape American racial prejudice in Paris—"Wasn't white nowhere, black wasn't." A section of poetry included contributions from **Countée Cullen**, Hughes, **Waring Cuney**, **Helene Johnson**, and **Arna Bontemps**.

Unlike *Opportunity* or *Crisis*, *Fire!!* included only literary writing, artwork by Nugent and Douglas, and editorials. The only thing resembling sociology to be found was **Arthur Huff Fauset's** essay "Intelligentsia," which sarcastically described this class of people: "He reads H. L. M. and George Jean Nathan, knows his Freud from cover to cover, and has an ability for spotting morons which is positively as uncanny as the ability of a Texas bloodhound to sniff a nigger."

With an irony bordering on the ridiculous, a cache of back issues of *Fire!!* burned in a fire, and Wallace Thurman was left in debt by the venture. (His associate editors were meant to contribute $50 apiece, but not all of them did.) Fewer than fifty copies survive in libraries today, but a facsimile edition was printed in 1982.

44

Fire!! A Quarterly Devoted to the Younger Negro Artists
November 1926

Wallace Thurman Collection

FIRE!!
DEVOTED TO YOUNGER NEGRO ARTISTS

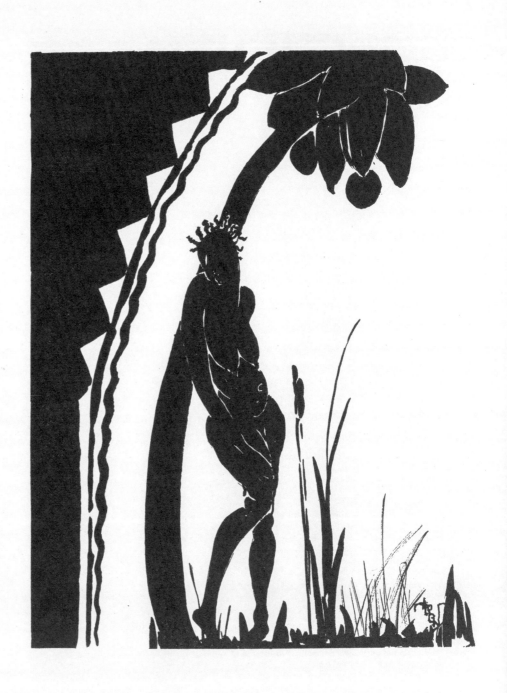

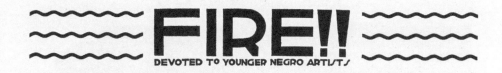

Cordelia the Crude

Physically, if not mentally, Cordelia was a potential prostitute, meaning that although she had not yet realized the moral import of her wanton promiscuity nor become mercenary, she had, nevertheless, become quite blasé and bountiful in the matter of bestowing sexual favors upon persuasive and likely young men. Yet, despite her seeming lack of discrimination, Cordelia was quite particular about the type of male to whom she submitted, for numbers do not necessarily denote a lack of taste, and Cordelia had discovered after several months of active observation that one could find the qualities one admires or reacts positively to in a varied hodge-podge of outwardly different individuals.

The scene of Cordelia's activities was The Roosevelt Motion Picture Theatre on Seventh Avenue near 145th Street. Thrice weekly the program changed, and thrice weekly Cordelia would plunk down the necessary twenty-five cents evening admission fee, and saunter gaily into the foul-smelling depths of her favorite cinema shrine. The Roosevelt Theatre presented all of the latest pictures, also, twice weekly, treated its audiences to a vaudeville bill, then too, one could always have the most delightful physical contacts . . . hmm. . . .

Cordelia had not consciously chosen this locale nor had there been any conscious effort upon her part to take advantage of the extra opportunities afforded for physical pleasure. It had just happened that the Roosevelt Theatre was more close to her home than any other neighborhood picture palace, and it had also just happened that Cordelia had become almost immediately initiated into the ways of a Harlem theatre chippie soon after her discovery of the theatre itself.

It is the custom of certain men and boys who frequent these places to idle up and down the aisle until some female is seen sitting alone, to slouch down into a seat beside her, to touch her foot or else press her leg in such a way that it can be construed as accidental if necessary, and then, if the female is wise or else shows signs of willingness to become wise, to make more obvious approaches until, if successful, the approached female will soon be chatting with her baiter about the picture being

shown, lolling in his arms, and helping to formulate plans for an after-theatre rendezvous. Cordelia had, you see, shown a willingness to become wise upon her second visit to The Roosevelt. In a short while she had even learned how to squelch the bloated, lewd faced Jews and eager middle aged Negroes who might approach as well as how to inveigle the likeable little yellow or brown half men, embryo avenue sweetbacks, with their well modeled heads, stickily plastered hair, flaming cravats ,silken or broadcloth shirts, dirty underwear, low cut vests, form fitting coats, bell-bottom trousers and shiny shoes with metal cornered heels clicking with a brave, brazen rhythm upon the bare concrete floor as their owners angled and searched for prey.

Cordelia, sixteen years old, matronly mature, was an undisciplined, half literate product of rustic South Carolina, and had come to Harlem very much against her will with her parents and her six brothers and sisters. Against her will because she had not been at all anxious to leave the lackadaisical life of the little corn pone settlement where she had been born, to go trooping into the unknown vastness of New York, for she had been in love, passionately in love with one John Stokes who raised pigs, and who, like his father before him, found the raising of pigs so profitable that he could not even consider leaving Lintonville. Cordelia had blankly informed her parents that she would not go with them when they decided to be lured to New York by an older son who had remained there after the demobilization of the war time troops. She had even threatened to run away with John until they should be gone, but of course John could not leave his pigs, and John's mother was not very keen on having Cordelia for a daughter-in-law — those Joneses have bad mixed blood in 'em—so Cordelia had had to join the Gotham bound caravan and leave her lover to his succulent porkers.

However, the mere moving to Harlem had not doused the rebellious flame. Upon arriving Cordelia had not only refused to go to school and refused to hold even the most easily held job, but had also victoriously defied her harassed parents so frequently when it came to matters of discipline that she soon found herself with a mesmerizing lack of

It is often taken as a sign of the great impact of the Harlem Renaissance's literature that a gossip rag like *The Inter-State Tattler*—which David Levering Lewis calls "Afro-America's most frivolous newspaper"—covered literary and legitimate theatrical events as if they were the latest celebrity dish.[74] Yet the commentary in the *Tattler* could also be seen as a sign of its serious commitment to reporting on the community.

Begun in February 1925, the *Tattler* was known for its multiple columns carrying numerous snippets of society news. These included "Social Snapshots," penned in "sparkling Harlemese"[75] by **Geraldyn Dismond**, the leading African American gossip columnist and sometime managing editor, as well as "About People," "People You Know," and "Club Scribblings," among others. Contributors from the Atlantic to the Great Plains delivered tidbits sorted by town, from Philadelphia to Scranton, Pennsylvania, to St. Louis, Missouri. With the tag line "Spicy. Interesting. Entertaining. The Best Advertising Medium," the *Tattler* attracted sponsors that included Small's Paradise and Club Ebony, as well as a horde of beauty products.

For all the *Tattler's* claims to "spiciness," Dismond covered the Harlem scene both high and low with equanimity. Of **Claude McKay's** shocking novel *Home to Harlem* she wrote drily, "although nothing is added to our glory [...McKay] has given what is unquestionably a picture of Harlem."[76] After attending one of Harlem's famous drag balls at Hamilton Lodge, she observed, "A costume ball can be a very tame thing, but when all the exquisitely gowned women on the floor are men and a number of the smartest men are women, then, we have something over which to thrill and grow round-eyed."[77] Displaying a particular fondness for heiress **A'Lelia Walker** and her parties, Dismond reported after a 1929 soiree: "Bacchus himself passed out before midnight and along about two o'clock the shade of Rabelais returned to its tomb with its head hanging low in defeat."[78]

Issues of *The Inter-State Tattler* are held by fewer than two dozen libraries; The James Weldon Johnson Memorial Collection has only seven from its seven-year weekly run, most of which were donated by **Dorothy Petersen**.

45

The Interstate Tattler
1925–1932

James Weldon Johnson Memorial Collection

TATTLER
The INTER-STATE
SOCIETY · THEATRICALS · SPORTS
A NATIONAL PICTORIAL WEEKLY
10¢ A COPY

Vol. III. NEW YORK, FRIDAY, DECEMBER, 9, 1927 No. 50

Wherever Society Moves Geraldyn's "Snap-shots" Follow

Geraldyne Dismond

Managing Editor of The Inter-State Tattler, was given first place among the Society writers in the 1927 Survey of The Negro Press.

EDITOR'S NOTE—*Miss Dismond is now attending the Negro fact-finding and stock-taking conference at Durham, N. C. She will cover the conference for The Tattler.*

Though he was not an anthropologist, **Sterling Brown**, like **Zora Neale Hurston**, was fascinated by African American folk tales and folklife and transformed those stories into poetic portraits of figures like Big Boy Davis and Slim Greer. Brown himself disavowed the "Harlem Renaissance" moniker in 1955 (he was one of the first historians of the period to do so), insisting that the phrase was promoted by New York publicity firms rather than actual artists, most of whom did not live in New York. Brown, who was born and raised in Washington, D.C., and educated at Williams College and Harvard, never lived in New York City and was often excluded from the more social aspects of the Renaissance. Though he did win an *Opportunity* prize in 1925 for an essay on the tenor **Roland Hayes**, he was left out of projects like *The New Negro* and *Fire!!*

Having studied English literature and earning a master's degree from Harvard in 1923, Brown took his first academic post teaching at Virginia Seminary in Lynchburg. It was in this position that Brown began seriously collecting the folklore and music of Virginia, visiting jook joints and barbershops as well as the countryside. Robert Stepto compares Brown to Hurston and **Jean Toomer**, writing, "Brown drew on his observations to produce a written vernacular literature that venerated black people of the rural South instead of championing the new order of black life being created in cities in the North. And like Toomer in particular, Brown's wanderings in the South represented not just a quest for literary material, but also an odyssey in search of roots more meaningful than what seemed to be provided by college in the North and black bourgeois culture in Washington."[79]

Brown befriended **James Weldon Johnson** in the late twenties as he was preparing a companion to Johnson's *Book of American Negro Poetry* to be used in teaching; Johnson himself would begin teaching literature and creative writing at Fisk University in 1931. By then at Howard University (where he would teach for 40 years), Brown was also at work on his major book of poetry, *Southern Road*, which would be published with Johnson's introduction in 1932. In January 1930, he describes a return to Virginia as "fertile in many ways. I saw Big Boy again, the hero of *When De Saints Go Marching Home;* ran across many interesting experiences." Johnson consulted with Brown, a respected literary critic, on his 1931 revision of *The Book of American Negro Poetry*, which would include for the first time poems by Brown, **Langston Hughes**, **Countée Cullen**, and **Gwendolyn Bennett**. Johnson also asked Brown to write the biography of Johnson for the volume's series of contributors' biographies.

Brown's star would rise in the 1930s after the publication of *Southern Road*. He was asked to head the Negro Affairs division of the Federal Writers Project from 1936-1939. In 1937, Brown won a Guggenheim Fellowship that enabled him to complete two major works of literary criticism, *The Negro in American Fiction* and *Negro Poetry and Drama*, both of which contributed to the nascent field of of African American literary studies.

46

Sterling Brown, Letters to James Weldon Johnson 1930–1938

James Weldon Johnson and Grace Nail Johnson Papers

12018

WESTERN UNION 1931 JAN 17

The filing time as shown in the date line on full-rate telegrams and day letters, and the time of receipt at destination as shown on all messages, is STANDARD TIME.

Received at 210 West 135th Street, New York

NV131 45 DL CNT PCTNS=WASHINGTON DC 17 159P

JAMES WELDON JOHNSON=

187 WEST 135 ST=

REVISION PERFECTLY SATISFACTORY SUGGEST BORN IN ETC HE WAS
EDUCATED ETC IN THAT TIME; STUDIED PAGE TWO RAMIFICATIONS,
CONTRIBUTION FOR CONTRIBUTOR SPELLING OF LEISURELY OTHERWISE
SATISFACTORY SPECIAL DELIVERY MAILED TONIGHT CONCERNING
PROOF PLEASE LET MR ROGERS KNOW YOU HAVE HEARD FROM ME=

 STERLING A BBROWN.

Born in 1891 in Alabama and raised in the all-black town of Eatonville, Florida, the larger-than-life **Zora Neale Hurston** could not be bound by such strictures as birthdate. Around the time she moved north, first to attend Howard University in 1923-1924 and then to continue her education at Barnard and Columbia in 1925, she lopped 10 years from her age, telling friends she had been born in 1901. Though **Jessie Fauset**, born 1882, and **Claude McKay**, born 1889, were occasionally honorary members of the "younger generation," Hurston must have decided it was preferable to claim her status as a child of the twentieth century.

Quickly befriending many of the younger writers around Harlem, Hurston took two second prizes in the inaugural *Opportunity* contest in 1925: one for her short story "Spunk," which would appear later that year in **Alain Locke's** *New Negro*, and one for her play *Color Struck*, which was included in the journal *Fire!!* After collecting her accolades at the May 1925 awards dinner, the famously charismatic Hurston went home having sufficiently ingratiated herself to **Fannie Hurst** to be hired as Hurst's assistant. She would serve as partial inspiration for Hurst's novel *Imitation of Life*.

Hurston studied anthropology at Barnard, where she completed her B.A. in 1928, and went on to spend two years at graduate school at Columbia, studying under **Franz Boas**, the father of American anthropology, who emphasized cultural pluralism and the concept that race is a cultural construction. With an uncanny ability to make people at ease, Hurston excelled at anthropological field work, collecting folklore with Boas's encouragement throughout the South and the West Indies. Hurston habitually collected and compiled examples of culture from life around her, as with the list "Harlem Slanguage," which she composed to accompany her story "Book of Harlem," a faux-Biblical allegory of the neighborhood. Defined terms included "Mister Charlie," "gut-foot," "first thing smoking," "jump salty," and "Ginny Gall." She gives at least eight ways to describe a person's skin tone, more than that many ways to describe a person's hair, and countless ways to refer to sex, sex organs, and sexuality. The thrill of collecting shines through all Hurston's collections. In 1926, having just met **Carl Van Vechten**, Hurston wrote excitedly, "I have found something this time which I am sure will stir you up immensely. I HAVE COME UPON THE MOST MARVELLOUS SET OF SPIRITUALS SINGERS YET! I can get three of them to come down to your place with their tambourines, guitars, etc. whenever you say."[80]

Hurston published three novels in the 1930s, including her most celebrated work, *Their Eyes Were Watching God* (1937), which showcases her lifelong concerns with relationships between men and women, southern folk life, and the formation of communities. When Van Vechten founded the James Weldon Johnson Memorial Collection, Hurston contributed several of her manuscripts, including those for *Their Eyes Were Watching God* and her autobiography *Dust Tracks on a Road*, published in 1942. Partly because Hurston died in obscurity after her career declined later in her life, these manuscripts and a few other small caches, including at the Library of Congress and University of Florida, are nearly all that remains of the writer whom **Langston Hughes** called "a perfect book of entertainment in herself."[81]

47

Zora Neale Hurston, Manuscripts
ca. 1930–1941

Zora Neale Hurston Collection

44. THE WAGON, police patrol.

45. THE MAN, t ⸺⸺⸺ ⸺⸺⸺rful boss.

46. GET YOU T�⸺ ⸺ ⸺⸺⸺ ⸺⸺ to force the opponent

~~64.~~ SELL OU⸺ 17. MISTER CHARLIE, white man

48. GO WHEN 18. OFAY, white pers⸺

 19 ⸺

HARLEM SLANGUAGE

Zora Neale Hurston

1. SUGAR HILL, the northwest corner of Harlem near Washington Heights
 where most of the newest-occupied large apartment houses
 for Negroes. Mostly occupied by professional Negroes.
 Walter White, and others of his financial standing live
 at 409 Edgecombe.

 NOTE: It is interesting to note that many expression
 that come from the South as this one does, has
 been distorted. In numerous southern towns, the
 Negro red light district is called "Sugar Hill."
 The term was probably overheard without under-
 standing its original meaning.

2. Pilch, house or apartment. Residence

3. SCOOTER-POOKER, a professional at sex.

4. SCOOTER-POOKING, practising, or the act of sex.

5. JELLY, sex

6. JELLY BEAN, a man who lives by sex, a pimp.

7. P.I. , a pimp.

8. SWEET-BACK, a pimp

9. BuLL-DIKER, a flatter, a Lesbian

10. FLATTER, Lesbian

11. SCRAP IRON, cheap likker

12. CONK BUSTER, cheap likker

13. REEFER, marijuana cigarette

14. DRAG, a reefer

15. MONKEY CHASER, a West Indian

16. MISS ANNE, a white woman

The social and economic life of working class Harlem coalesces in these cards, collected by **Langston Hughes**. As the mass migration of southern African Americans to northern cities like New York peaked in the 1920s, new residents were crowded into small tenement apartments and charged exploitatively high rents, sometimes as much as double or triple what white counterparts might pay. As historian David Levering Lewis writes: "Rent parties were a function first of economics, whatever their overlay of camaraderie, sex, and music. In its 1927 report on 2,326 Harlem apartments, the Urban League found that 48 percent of the renters spent more than twice as much of their income on rent as comparable white New Yorkers. For a four-room apartment (more than half of the Urban League's sample), the average monthly rent was $55.70; average family income was about $1,300. The New York white equivalent was $32.43 in rent on a family income of $1,570."[82]

Enterprising residents would organize house rent parties to cover their expenses. They provided the space and the live music—a piano player or even a three-piece band—and for between ten and fifty cents, guests could party all night long, while the hosts raised enough money to make ends meet. Prohibition-era home-distilled liquors and buffet spreads of home-cooked foods brought in additional revenue.

Hosts could print up cards advertising their "Social Whist Parties" at any number of local cheap printers, including the Wayside Printer, a man who wheeled a printing press down the streets of Harlem. Amused by the playful rhyming slogans and doggerel that appeared on most cards, Hughes began collecting them, amassing dozens of examples. In his autobiography *The Big Sea*, Hughes suggested that rent parties existed partly so that Harlemites could escape the staring eyes of white voyeurs. "Non-theatrical, non-intellectual Harlem was an unwilling victim of its own vogue."[83] For Hughes, who frequently claimed an affinity with ordinary working folk, the rent party card collection served as evidence of his credentials.

Rent parties were a source of contention in one of the major dust-ups over the period's aesthetics. **Wallace Thurman** and **William Jourdan Rapp's** play *Harlem* (1929), the first play by an African American to be performed on Broadway, featured a rent party at the center of its melodramatic plot. The staging of house dancing and debauchery alarmed many African American critics, who denounced the play.

48

Langston Hughes's Collection of House Rent Party Cards ca. 1925–ca. 1960

Langston Hughes Papers

If YOU want to have FUN on this NIGHT,
Just Straighten up and FLY right, at

A PARTY

Given By

ELLA & ANNA

2672-8th Ave., Apt. 7

Saturday & Sunday Nights *AUG. 5-6*

Tasty Refreshments Snappy Music

＊ If You Want A Real Good Time, ＊
Keep This Party Date in Mind

A Social Whist Party

GIVEN BY

CARRIE & LAWRENCE

At 2613 - 8th Avenue, Apartment 4

On Saturday Evening, October 9th, 1943

❋ SWING MUSIC AND REFRESHMENTS ❋

If Sweet Mamma is running wild, and you are looking
for a Do-right child, just come around and
linger awhile at a

Social Whist Party

GIVEN BY

PINKNEY & EPPS

260 West 129th Street *June 9* Apartment 10

SATURDAY EVENING, ~~MAY 12th~~ 1928

GOOD MUSIC REFRESHMENTS

When your lover has gone forget your lonely
hour get a new one at

A SOCIAL WHIST PARTY

given by

Brown & Clarke

265 West 146th Street Apt. 3

Sunday Evening September 20th, 1931

Snappy Music Refreshments Served
from 3 p.m. until? Buffet Lunch Free

You can wake up the Devil, raise all the Hell;
No one will be there to go home and tell.

— A SOCIAL PARTY —

GIVEN BY

ROSE

— A T —

2213 Eighth Avenue Apartment 5

Friday evening, March 18th, 1955

from 9 P. M. until ? ? ?

LATEST ON WAX —— REFRESHMENTS

35 Cents With Ticket (Pay at Door) 50 Cents Without

A Party given at 8 in the evening,
Come Ivy League, Collegiate or Bohemian!

＊ ## A SOCIAL DANCE ＊

—Given By—

WANDA and BERT

AT 217 WEST 127th ST. Apt. 8- H N. Y. C.

Saturday evening, January 19th, 1957

from 8:00 o'clock until ?

35 cents With 40 cents Without

If you like A Real Good Time, Drop around
where Everything is Fine, at

A SOCIAL WHIST PARTY

GIVEN BY

GERTRUDE BOND

AT 149 W. 140TH STREET, APT. 11

SATURDAY EVE., SEPT. 19, 1931

McWalker at the piano Refreshments

Fly Right into

A PARTY

Given By

BOILER RED & BUSTER

2473 Seventh Ave., Apt. 3-N

Sunday Evening, July 2nd, 1944

Tasty Refreshments Snappy Music

The seventh of fourteen children, born in 1892 in Green Cove Springs, Florida (a small town near Jacksonville), **Augusta Savage** had devout parents who discouraged her interest in art. Nevertheless, she arrived in New York in 1921 to study sculpture at Cooper Union, where she had won a full scholarship (much like **Zora Neale Hurston**, she took a decade off her age when she enrolled); she completed her four-year course in three years. In 1923, Savage became a cause célèbre when she publicized her rejection from a French summer program on the basis of her color.

While she supported herself by taking in laundry, Savage's first major commission was to sculpt a portrait bust of **W. E. B. Du Bois** for the Harlem branch of the New York Public Library. This piece earned her other projects, including a bust of **Marcus Garvey**. One of her best known works, *Gamin*, a portrait of her nephew, earned her a Rosenwald Fellowship to study in Paris in 1929. There, she met African American painters **Henry Ossawa Tanner** and **Hale Woodruff**. A second Rosenwald Fellowship and support from the Carnegie Foundation enabled her to remain in Paris and tour Europe for an additional two years.

Upon her return to the United States, Savage founded The Savage Studio of Arts and Crafts in Harlem, an adult arts education studio where her students included Jacob Lawrence, Norman Lewis, and influential psychologist Kenneth B. Clark. In 1937, her studio became the model for the Harlem Community Art Center, founded under the Federal Art Project, and Savage was made its director. The same year, the New York World's Fair Board of Design commissioned Savage to create a sculpture on the theme "Negro Contribution to Music, especially Song." Savage used **James Weldon and J. Rosamond Johnson's**

song "Lift Every Voice and Sing" as her inspiration, designing a harp with twelve singers of different heights forming the strings, and an arm and hand forming the sounding board. A crouching figure held the harp's pedal. The finished work would serve as a tragic, though fitting tribute to James Weldon Johnson, who was killed in a car accident in June 1938. Cast in plaster and painted with a black basalt finish, the sixteen-foot work—which fair organizers named "The Harp" against Savage's wishes—was exhibited in the courtyard of the Contemporary Arts building at the 1939 World's Fair. Unfortunately, though the work was popular, funds to cast it did not materialize, and the plaster was destroyed when the fair closed. Savage cast miniature replicas with copper, black, and silver patinas, like the one she gave to **Grace Nail Johnson**, James Weldon Johnson's widow.

Though she had taken a leave of absence from the Harlem Community Art Center to work on *Lift Every Voice and Sing*, Savage found herself displaced by acting director **Gwendolyn Bennett**. Struggling to find work and depressed—and, as new scholarship has suggested, fleeing the harassment of eccentric partycrasher Joseph Gould—she retreated to a home in the Catskills town of Saugerties, New York.[84] There, she supported herself raising chickens and pigeons and tending laboratory mice. She continued to sculpt in clay, but few of these works were known before her death in 1962.

49

Augusta Savage, *Lift Every Voice and Sing* 1939

James Weldon Johnson Memorial Collection

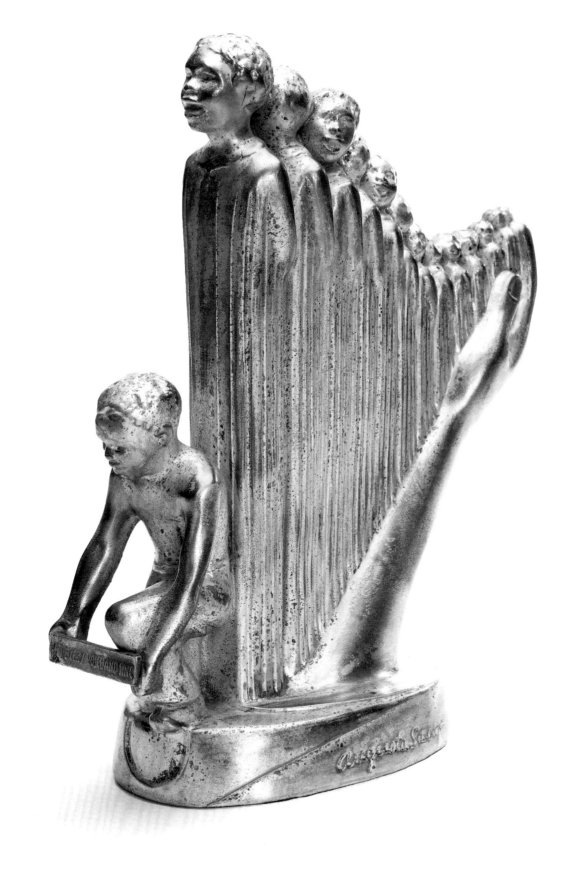

Announcing the creation of the James Weldon Johnson Memorial Collection of Negro Arts and Letters Founded by **Carl Van Vechten**—a mouthful of a title—to *Crisis* readers in the summer of 1942, Van Vechten wrote that Yale University Librarian **Bernhard Knollenberg** used "precisely the right words to convince me" to donate his library of African American literature to Yale: Knollenberg had said, "We haven't any Negro books at all."[85] (This was, in fact, hyperbole on Knollenberg's part, but near enough to the truth.)

Van Vechten urged readers to donate "any manuscripts or books written by any one with Negro blood, and the best books about Negroes written by white men [...], interesting photographs, rare first editions of music, phonograph records, programs of plays or concerts, and especially letters." Help had already come from **Dorothy Peterson, Walter White, Harold Jackman, Langston Hughes, Claude McKay, Arthur Spingarn, Fannie Hurst, Amy Spingarn** (the widow of **Joel Spingarn**), and **Dorothy West**. Helene Grant and Georgia Washington had contributed an unpublished manuscript by **Wallace Thurman**, who had died in 1934.

In the aftermath of Johnson's horrific death in a car accident in June 1938, Van Vechten had formed the James Weldon Johnson Memorial Committee, chaired by **Theodore Roosevelt** and including **Eleanor Roosevelt, Marian Anderson, Walter White, W. E. B. Du Bois, Duke Ellington**, and Hughes. Plans for a statue designed by **Richmond Barthé** were ultimately disrupted by the country's entry into the Second World War.[86] Meanwhile, Van Vechten had begun to pursue an alternative: he wanted to find a home for his collection of African American books, and since the New York Public Library already had the Schomburg Collection, he decided to look beyond the city. Yale would become the first predominantly white academic institution to begin seriously collecting African American literature.

In his catalogue of the collection, which runs to over 650 pages, Van Vechten lists his gifts and those of others. (By the time the collection formally opened in 1950, Van Vechten, with the help of Peterson and Jackman, had received materials from more than 150 people.) On Van Vechten's list, authors are labeled Negro-N, White-W, or Don't Know-? Some entries merit extended annotations or even biographies, as for **A'Lelia Walker, Nora Holt, Josephine Baker**, and **Gladys Bentley**. Regarding his fourteenth edition of Du Bois's *The Souls of Black Folk*, Van Vechten writes, "This book is important and a copy of the rare first edition should be in the collection" (one was donated by Jerome Bowers Petersen, founder of *The New York Age* and father of Dorothy). After listing two pieces of sheet music by **Andy Razaf** (who had mentioned Van Vechten by name in his song "Go Harlem") Van Vechten notes: "Imagery comes natural to the Negro. He is also accustomed to inventing phrases which will deceive and confuse the white man. In these songs these gifts are used deliberately to make obscenity more palatable."

Much of the material in the foregoing pages came from the gifts listed here, and the rest has been added in the intervening years thanks to the momentum built by Van Vechten and his collaborators. Their labor of love for the memory of Johnson, and of a time, have crafted a collection for the ages.

50

Carl Van Vechten, List of Books Donated to the James Weldon Johnson Memorial Collection 1941–ca. 1950

Carl Van Vechten Papers

THE JAMES WELDON JOHNSON MEMORIAL COLLECTION OF NEGRO ARTS AND LETTERS,
FOUNDED BY CARL VAN VECHTEN

THE AMERICAN MERCURY, CONTINUED

MEMORIAL

...)(w): The Etiquette of Slavery, page

THE JAMES
ED BY CAR...
Carl Van...

12 Volum...

American Mercury, ...by ...about ...negroes. The ...
...important papers are ... included in this collection. ...
...are indicated in Carl Van Vechten' handwriting, on the ...
...each volume.

1. Volume I, page ... : ... All God's Chillun Got Wings ...

3. Volume IV: ... Africanus, page 83.

4. ... Picture and Dance, page

... Claude McKay(w): ... Joseph I, page ...

... : After Africa, ... to the South, ...

... : ... Garden(w): ...

... James Weldon Johnson(): ... Poem, ... the ... of ...

... Funeral Sermon.

... (): ... Speeches (Jan), page ...

... (): ...

... (): ... Through Color,

... Prejudices.

8. ...

9. ...

10. ...

11. ...

NOTES TO THE ALBUM

MUSTER

6
Charles Martin, "Negro Silent Protest Parade," July 24, 1917. Papers of the National Association for the Advancement of Colored People, Part 7: The Anti-Lynching Campaign.

7
James Weldon Johnson, *Along this Way* (New York: The Viking Press, 1933), 322.

8
George Hutchinson, *The Harlem Renaissance in Black and White*, (Cambridge, MA: Belknap Press, 1995).

9
Wayne F. Cooper, *Claude McKay: Rebel Sojourner in the Harlem Renaissance* (Baton Rouge: Louisana State University Press, 1987), 137.

10
Winston James, "Claude McKay," in *Encyclopedia of the Harlem Renaissance*, eds. Cary D. Wintz and Paul Finkelman (New York: Routledge, 2004), 778.

11
Arna Bontemps, "Introduction," *Cane*, (New York: Harper & Row, 1969), vii.

12
Qtd. in Bontemps, viii.

13
Rudolph P. Byrd and Henry Louis Gates, Jr., "'Song of the Son': The Emergence and Passing of Jean Toomer," in *Cane* (New York: W.W. Norton & Company, 2011), lxi.

14
Langston Hughes, *The Big Sea*, (New York: Hill and Wang, 1993 [1940]), 218.

15
Jessie Fauset, Letter to Langston Hughes, January 21, 1926, Langston Hughes Papers, James Weldon Johnson Memorial Collection, Beinecke Rare Book & Manuscript Library.

16
Theodore Kornweibel, "The Messenger," in Wintz and Finkelman, 785.

ENTERTAIN

17
James Weldon Johnson, *Black Manhattan* (New York, Alfred A. Knopf, 1930), 188.

18
Barbara S. Glass, *African American Dance: An Illustrated History* (Jefferson, N.C.: McFarland & Co., 2007), 179.

19
Heywood Broun, "As We Were Saying," *New-York Tribune*, July 3, 1921.

20
Theophilus Lewis, "Theatre," *Messenger*, January 1925, 62.

21
Johnson, *Black Manhattan*, 175.

22
Steven Watson, *The Harlem Renaissance: Hub of African American Culture, 1920-1930* (New York: Pantheon Books, 1995), 127.

23
Dorothy Heyward and DuBose Heyward, *Porgy: A Play in Four Acts* (Garden City, NY: Doubleday, Doran & Company, inc., 1928), x.

24
Eugene Levy, *James Weldon Johnson, Black Leader, Black Voice* (Chicago: University of Chicago Press, 1973), 297.

25
"Trombones," *Time*, June 6, 1927, 48.

26
Qtd. in David Krasner, *A Beautiful Pageant: African American Theatre, Drama, and Performance in the Harlem Renaissance, 1910-1927* (New York: Palgrave Macmillan, 2002), 71.

27
W. C. Handy, *Father of the Blues* (New York: The Macmillan Company, 1941), 14.

28
Rocio Aranda-Alvarado, "Miguel Covarrubias," in Wintz and Finkelman, 258.

29
Qtd. in James Haskins, *Black Dance in America: A History Through Its People* (New York: T.Y. Crowell, 1990), 43.

GET TOGETHER

30
Hutchinson, *The Harlem Renaissance in Black and White*, 392.

31
Hutchinson, 50-59.

32
Charles S. Johnson, "Editorials," *Opportunity,* September 1924, 24.

33
David Levering Lewis, *When Harlem Was in Vogue* (New York: Penguin, 1997 [1981]), 120.

34
Lewis, 166.

35
Richard Bruce Nugent, "On the Dark Tower," in *Gay Rebel of the Harlem Renaissance*, ed. Thomas Wirth (Durham, N.C.: Duke University Press, 2002), 219.

36
Qtd. in Bruce Kellner, *Carl Van Vechten and the Irreverent Decades* (Norman, OK: University of Oklahoma Press, 1968), 202.

37
Ralph Ellison, *Invisible Man* (New York: Random House, 1952), 36.

38
Langston Hughes, Letter to Claude McKay, Claude McKay Collection, James Weldon Johnson Memorial Collection, Beinecke Rare Book & Manuscript Library.

39
Arnold Rampersad, *The Life of Langston Hughes*, vol. 1 (New York: Oxford University Press, 1986), 63.

40
Rampersad, 67.

41
Clarence Darrow, Letter to James Weldon Johnson, December 1927, James Weldon Johnson and Grace Nail Johnson Papers, James Weldon Johnson Memorial Collection, Beinecke Rare Book & Manuscript Library.

42
Allyson Hobbs, *A Chosen Exile: A History of Racial Passing in American Life* (Cambridge, MA: Harvard University Press, 2014), 199.

43
Thadious Davis, *Nella Larsen, Novelist of the Harlem Renaissance* (Baton Rouge, LA: Louisiana State University Press, 1994), 218.

44
Kellner, *Carl Van Vechten and the Irreverent Decades*, 162.

45
Emily Bernard, *Carl Van Vechten and the Harlem Renaissance: A Portrait in Black and White* (New Haven, CT: Yale University Press, 2012), 6.

46
Richard J. Powell, "The Aaron Douglas Effect," in *Aaron Douglas: African American Modernist* (New Haven, CT: Yale University Press, 2007), 57.

47
Elizabeth McHenry, *Forgotten Readers: Recovering the Lost History of African American Literary Societies* (Durham, NC: Duke University Press, 2002), 272.

48
Gwendolyn Bennett, "The Ebony Flute," *Opportunity*, October 1926, 322.

49
Gwendolyn Bennett, "The Ebony Flute,' *Opportunity,* July 1927, 212.

50
Bruce Kellner, *Carlo Among the Muses* (New Haven, CT: Beinecke Rare Book & Manuscript Library, 2007).

51
Zora Neale Hurston, Letter to Carl Van Vechten, December 10, 1934, Carl Van Vechten Papers.

52
Kellner, *Carlo Among the Muses.*

GARNER

53
Lewis, *When Harlem Was in Vogue*, 181.

54
W. E. B. Du Bois, "The Browsing Reader," *Crisis*, June 1928, 202.

55
Bruce Kellner, ed., *The Harlem Renaissance: An Historical Dictionary for the Era* (Westport, CT: Greenwood Press, 1984), 338.

56
Langston Hughes, *Fine Clothes to the Jew* (New York: Alfred A. Knopf, 1927), 85.

57
Rampersad, *The Life of Langston Hughes*, 141.

58
Qtd. In Rampersad, 140.

59
"Editorials," *Opportunity,* September 1924, 24.

60
Lewis, *When Harlem Was in Vogue,* 97.

61
George S. Schulyer, "Shafts and Darts," *The Messenger*, June 1924, 183.

62
Margaret Walker, "New Poets" *Phylon* 11, no. 4 (December 1950): 345.

63
Kellner, ed., *The Harlem Renaissance: An Historical Dictionary for the Era*, 237.

64
Rampersad, *The Life of Langston Hughes*, 157.

65
Hughes, *The Big Sea*, 312.

66
Lawrence P. Jackson, *The Indignant Generation: A Narrative History of African American Writers and Critics, 1934-1960* (Princeton: Princeton University Press, 2011), 17.

COLLECT

67
Paul Kellogg, Letter to Alain Locke, qtd. in Hutchinson, *The Harlem Renaissance in Black and White*, 393.

68
Hutchinson, 394.

69
Hutchinson, 396.

70
Arnold Rampersad, "Introduction," *The New Negro*, ed. Alain Locke (New York: Simon and Schuster, 1997 [1925]), xxiii.

71
Robert Hayden, "Preface," *The New* Negro, ed. Alain Locke (New York: Atheneum, 1968), xiii.

72
Qtd. in Martha Jane Nadell, *Enter the New Negroes: Images of Race in American Culture* (Cambridge, MA: Harvard University Press, 2004), 57.

73
Alain Locke, ed., *The New Negro: An Interpretation* (New York: Simon & Schuster, 1997 [1925]), 419-20.

74
Lewis, *When Harlem Was in Vogue*, 126.

75
Hughes, *The Big Sea*, 243.

76
Qtd. in Lewis, *When Harlem Was in Vogue,* 225.

77
Seth Clark Silberman, "Inter-State Tattler," in Wintz and Finkelman, 605.

78
Qtd. in Silberman, 605.

79
Robert Stepto, "Brown, Sterling Allen," *American National Biography Online,* February 2000, http://www.anb.org/articles/16/16-00200.html.

80
Zora Neale Hurston, Letter to Carl Van Vechten, January 5, 1926, Carl Van Vechten Papers.

81
Hughes, *The Big Sea*, 239.

82
Lewis, *When Harlem Was in Vogue*, 108.

83
Hughes, *The Big Sea*, 229.

84
Jill Lepore, *Joe Gould's Teeth* (New York: Knopf, 2016). Eve M. Kahn, "Antiques," *New York Times,* March 25, 2016.

85
Carl Van Vechten, "The J. W. Johnson Collection at Yale," *Crisis,* July 1942, 222.

86
Bernard, *Carl Van Vechten and the Harlem Renaissance.*

SELECTED BIBLIOGRAPHY OF HISTORY AND CRITICISM

Baker, Houston A. *Modernism and the Harlem Renaissance*. Chicago: University of Chicago Press, 1987.

Bernard, Emily. *Carl Van Vechten and the Harlem Renaissance: A Portrait in Black and White*. New Haven, CT: Yale University Press, 2012.

Bontemps, Arna, ed. *The Harlem Renaissance Remembered*. New York: Dodd, Mead, 1972.

Boyd, Valerie. *Wrapped in Rainbows: The Life of Zora Neale Hurston*. New York: Scribner, 2003.

Brown, Sterling. "The New Negro in Literature." *A Son's Return: Selected Essays of Sterling A. Brown*. Ed. Mark A. Sanders. Boston: Northeastern University Press, 1996. 184-203.

Cooper, Wayne F. *Claude McKay: Rebel Sojourner in the Harlem Renaissance*. Baton Rouge: Louisiana State University Press, 1987.

Davis, Thadious. *Nella Larsen, Novelist of the Harlem Renaissance: A Woman's Life Unveiled*. Baton Rouge: Louisiana State University Press, 1994.

Earle, Susan. *Aaron Douglas: African American Modernist*. New Haven, CT: Yale University Press, in association with Spencer Museum of Art, University of Kansas, 2007.

Edwards, Brent Hayes. *The Practice of Diaspora: Literature, Translation, and the Rise of Black Internationalism*. Cambridge, MA: Harvard University Press, 2003.

Fabre, Geneviève, and Michael Feith, eds. *Temples for Tomorrow: Looking Back at the Harlem Renaissance*. Bloomington: Indiana University Press, 2001.

Glass, Barbara S. *African American Dance: An Illustrated History*. Jefferson, NC: McFarland & Co., 2007.

Goeser, Caroline. *Picturing the New Negro: Harlem Renaissance Print Culture and Modern Black Identity*. Lawrence: University Press of Kansas, 2007.

Huggins, Nathan Irvin. *The Harlem Renaissance*. New York: Oxford University Press, 2007 [1971].

Hughes, Langston. *The Big Sea*. New York: Hill and Wang, 1993 [1940].

Hutchinson, George. *The Harlem Renaissance in Black and White*. Cambridge, MA: Belknap Press of Harvard University Press, 1995.

____. *In Search of Nella Larsen: A Biography of the Color Line*. Cambridge, MA: Belknap Press of Harvard University Press, 2006.

Johnson, James Weldon. *The Autobiography of an Ex-Colored Man: Authoritative Text, Backgrounds and Sources, Criticism*. Ed. Jacqueline Goldsby. New York: W. W. Norton & Company, 2015.

____. *Black Manhattan*. Boston: Da Capo Press, 1991 [1930].

Kellner, Bruce. *Carl Van Vechten and the Irreverent Decades*. Norman: University of Oklahoma Press, 1968.

____, ed. *The Harlem Renaissance: An Historical Dictionary for the Era*. Westport, CT: Greenwood Press, 1984.

Kirschke, Amy Helene. *Aaron Douglas: Art, Race, and the Harlem Renaissance*. Jackson: University of Mississippi Press, 1995.

Krasner, David. *A Beautiful Pageant: African American Theatre, Drama, and Performance in the Harlem Renaissance, 1910–1927*. New York: Palgrave Macmillan, 2002.

Levy, Eugene. *James Weldon Johnson, Black Leader, Black Voice*. Chicago: University of Chicago Press, 1973.

Lewis, David Levering. *When Harlem Was in Vogue*. New York: Penguin Books, 1997 [1981].

Mitchell, Ernest Julius II. "'Black Renaissance': A Brief History of the Concept." *Amerikastudien / American Studies* 55, no. 4 (2010): 641–65.

Nadell, Martha Jane. *Enter the New Negroes: Images of Race in American Culture*. Cambridge, MA: Harvard University Press, 2004.

Nugent, Richard Bruce. *Gay Rebel of the Harlem Renaissance*. Ed. Thomas Wirth. Durham, NC: Duke University Press, 2002.

Rampersad, Arnold. *The Life of Langston Hughes*. New York: Oxford University Press, 1986-1988.

Singh, Amritjit, William S. Shiver, and Stanley Brodwin, eds. *Harlem Renaissance: Revaluations*. New York: Garland, 1989.

Toomer, Jean. *Cane: Authoritative Text, Contexts, Criticism*. 2nd ed. Edited by Rudolph P. Byrd and Henry Louis Gates, Jr. New York: W. W. Norton & Company, 2011.

Singh, Amritjit, William S. Shiver, and Stanley Brodwin, eds. *Harlem Renaissance: Revaluations*. New York: Garland, 1989.

Wall, Cheryl. *Women of the Harlem Renaissance*. Bloomington: Indiana University Press, 1995.

Watson, Steven. *The Harlem Renaissance: Hub of African American Culture, 1920–1930*. New York: Pantheon Books, 1995.

Wintz, Cary D. *Black Culture and the Harlem Renaissance*. Houston, TX: Rice University Press, 1988.

Wintz, Cary D. and Paul Finkelman, eds. *Encyclopedia of the Harlem Renaissance*. New York: Routledge, 2004.

CHECKLIST

1
Photographs of the Negro Silent Protest Parade, 1917
Silver gelatin print
James Weldon Johnson Memorial Collection

2
Claude McKay
Harlem Shadows
First Edition, Harcourt, Brace and Company, 1922
James Weldon Johnson Memorial Collection

3
Almanac of the Universal Negro Improvement Association, 1922
James Weldon Johnson Memorial Collection

4
James Weldon Johnson
The Book of American Negro Poetry
First Edition, Harcourt, Brace and Company, 1922
James Weldon Johnson Memorial Collection

5
Jean Toomer
Cane
First Edition, Boni & Liveright, 1923
James Weldon Johnson Memorial Collection

Jean Toomer
Journal, 1920
Jean Toomer Papers
James Weldon Johnson Memorial Collection

6
The Crisis: A Record of the Darker Races, 1910–
James Weldon Johnson Memorial Collection

7
Opportunity: A Journal of Negro Life, 1923–1942
James Weldon Johnson Memorial Collection

8
Langston Hughes
"The Negro Artist and the Racial Mountain"
The Nation, volume 122, number 3181 (June 23, 1926)
Yale Collection of American Literature

9
The Messenger, 1917–1928
James Weldon Johnson Memorial Collection

10
Various Songs from *Shuffle Along*
M. Witmark & Sons, 1921
James Weldon Johnson Memorial Collection

11
Edward Steichen
Portrait of Florence Mills, 1924
Silver gelatin print
James Weldon Johnson Memorial Collection

12
Program, *All God's Chillun Got Wings*, 1924
Clippings File of the James Weldon Johnson Memorial Collection

Photographs of Paul Robeson, 1925–1937
Silver gelatin print
James Weldon Johnson Memorial Collection

13
E. Sims Campbell
Night Club Map of Harlem, 1932
Ink and watercolor on illustration board
James Weldon Johnson Memorial Collection

14
Postcards of Josephine Baker
James Weldon Johnson Memorial Collection

15
Advertisement for the Theatre Guild's *Porgy*, 1927
Theatre Guild Archive
Yale Collection of American Literature

Photograph of the Cast of *Porgy*, Atlantic City, New Jersey, 1929
Silver gelatin print
Richard Bruce Nugent Papers
James Weldon Johnson Memorial Collection

16
Aaron Douglas
Prodigal Son (artwork for *God's Trombones*)
Gouache on paper
James Weldon Johnson and Grace Nail Johnson Papers
James Weldon Johnson Memorial Collection

17
Photographs of Ethel Waters, ca. 1925–1927
Silver gelatin print
James Weldon Johnson Memorial Collection

18
Photograph of Bill Robinson inscribed to Carl Van Vechten, 1928
Silver gelatin print
James Weldon Johnson Memorial Collection

19
James Van Der Zee
Couple, 1932
Silver gelatin print
Printed for *Eighteen Photographs*, Graphics International Ltd. 1974
James Weldon Johnson Memorial Collection

20
Miguel Covarrubias
Drawing of W.C. Handy inscribed by Handy to Langston Hughes, 1926/1942
Langston Hughes Papers
James Weldon Johnson Memorial Collection

21
Stephen Longstreet
Harlem Sketchbook, 1925–1939
Pencil and watercolor on paper
Stephen Longstreet Papers
Yale Collection of American Literature

22
Charles S. Johnson
Dinner invitation to Jean Toomer, March 6, 1924
Jean Toomer Papers
James Weldon Johnson Memorial Collection

23
James Van Der Zee
The Valentine Tea at Walker Shop #1, 1929
Silver gelatin print
James Weldon Johnson Memorial Collection

24
Gwendolyn Bennett
Letters to Harold Jackman, 1925–1926
James Weldon Johnson Collection Files
James Weldon Johnson Memorial Collection

25
Photograph of Jessie Fauset, Langston Hughes,
and Zora Neale Hurston beside *Lifting the Veil*, 1927.
Silver gelatin print
Langston Hughes Papers
James Weldon Johnson Memorial Collection

26
Countée Cullen
Letter to Langston Hughes, May 14, 1924
Langston Hughes Papers
James Weldon Johnson Memorial Collection

27
Alain Locke
Letters to Langston Hughes, 1922–1931
Langston Hughes Papers
James Weldon Johnson Memorial Collection

28
Guest Book from the Manhattan home of James Weldon
and Grace Nail Johnson, 1923–1931
James Weldon Johnson and Grace Nail Johnson Papers
James Weldon Johnson Memorial Collection

29
Nella Larsen
Letters to Carl Van Vechten, 1925–1934
Carl Van Vechten Papers
James Weldon Johnson Memorial Collection/
Yale Collection of American Literature

30
Aaron Douglas
Mural design for Carl Van Vechten's bathroom, 1927
Gouache on illustration board
Carl Van Vechten Papers
James Weldon Johnson Memorial Collection/
Yale Collection of American Literature

31
Georgia Douglas Johnson
Letter to James Weldon Johnson, January 3, 1930
Georgia Douglas Johnson Collection
James Weldon Johnson Memorial Collection

32
Langston Hughes
Letters to Claude McKay, 1925–1943
Claude McKay Collection
James Weldon Johnson Memorial Collection

Claude McKay
Letters to Langston Hughes, 1924–1943
Langston Hughes Papers
James Weldon Johnson Memorial Collection

33
Photograph of 267 West 136th Street (a.k.a. "Niggeratti Manor"), 1942
Silver gelatin print
Richard Bruce Nugent Papers
James Weldon Johnson Memorial Collection

34
Carl Van Vechten
Portraits of Zora Neale Hurston, 1934–1940
Silver gelatin prints
Carl Van Vechten Papers
James Weldon Johnson Memorial Collection/Yale Collection of
American Literature

35
A Collection of First Editions (with one second edition)

Walter White
Fire in the Flint, Alfred A. Knopf, 1924

Jessie Redmon Fauset
There Is Confusion, Boni & Liveright, 1924

Countée Cullen
Color, Harper & Brothers, 1925

Langston Hughes
The Weary Blues, Alfred A. Knopf, 1926

Eric Walrond
Tropic Death, Boni & Liveright, 1926

James Weldon Johnson
The Autobiography of an Ex-Coloured Man, Alfred A. Knopf, 1927

Nella Larsen
Quicksand, Alfred A. Knopf, 1928

Claude McKay
Home to Harlem, Harper & Brothers, 1928

Rudolph Fisher
The Walls of Jericho, Alfred A. Knopf, 1928

Wallace Thurman
The Blacker the Berry, The Macaulay Company, 1929

Arna Bontemps
God Sends Sunday, Harcourt, Brace and Company, 1931

George Schuyler
Black No More, The Macaulay Company, 1931

All James Weldon Johnson Memorial Collection

36
Spingarn Medal awarded to James Weldon Johnson, 1925
James Weldon Johnson and Grace Nail Johnson Papers
James Weldon Johnson Memorial Collection

37
Langston Hughes
Manuscript of *Fine Clothes to the Jew: Sixteen Blues Poems*, 1927
Langston Hughes Papers
James Weldon Johnson Memorial Collection

38
Advertisement for Albert & Charles Boni, Inc. "Negro Life Novel"
Contest, 1926
James Weldon Johnson and Grace Nail Johnson Papers
James Weldon Johnson Memorial Collection

39
Charlotte Osgood Mason (a.k.a. "Godmother")
Gift Tags for Langston Hughes, 1927–1931
Langston Hughes Papers
James Weldon Johnson Memorial Collection

40
Wallace Thurman
Infants of the Spring
First Edition, The Macaulay Company, 1932
James Weldon Johnson Memorial Collection

41
Survey Graphic, Harlem number, March 1925
James Weldon Johnson Memorial Collection

42
Alain Locke, Editor
The New Negro
First Edition, Albert & Charles Boni, Inc., 1925
James Weldon Johnson Memorial Collection

43
Winold Reiss, Checklist for "Exhibition of Recent Portraits of
Representative Negroes" at the 135th Street Library, 1925
Langston Hughes Papers
James Weldon Johnson Memorial Collection

44
Fire!! A Quarterly Devoted to the Younger Negro Artists, November 1926
Wallace Thurman Collection
James Weldon Johnson Memorial Collection

45
The Interstate Tattler, 1925–1932
James Weldon Johnson Memorial Collection

46
Sterling Brown
Letters to James Weldon Johnson, 1930–1938
James Weldon Johnson and Grace Nail Johnson Papers
James Weldon Johnson Memorial Collection

47
Zora Neale Hurston
Manuscripts, ca. 1930–1941
Zora Neale Hurston Collection
James Weldon Johnson Memorial Collection

48
Langston Hughes's Collection of House Rent Party Cards,
ca. 1925–ca. 1950
Langston Hughes Papers
James Weldon Johnson Memorial Collection

49
Augusta Savage
Lift Every Voice and Sing, 1939
James Weldon Johnson Memorial Collection

50
Carl Van Vechten
List of Books Donated to the James Weldon Johnson
Memorial Collection, ca. 1950
Carl Van Vechten Papers
James Weldon Johnson Memorial Collection/
Yale Collection of American Literature

INDEX OF PEOPLE

ACKNOWLEDGMENTS

This book would not have been possible, first and foremost, without the James Weldon Johnson Memorial Collection of African American Arts and Letters, and so I thank the collectors, donors, champions, and stewards of that collection, past and present.

Secondly, I want to express my boundless admiration and gratitude for the genius, care, and compassion with which Daphne Geismar designed this book, and for the talent and toil of Meredith Miller on the photography.

For their support, guidance, forbearance, and kindness I'm especially grateful to friends and colleagues Phoenix Alexander, Susan Brady, Lisa Conathan, David Driscoll, Patricia Fidler and colleagues at Yale University Press, Chris Gackenheimer, Jude Gackenheimer, Olivia Hillmer, Mike Kelleher, Nancy Kuhl, Lauren Langford, Megan Mangum, Sandra Markham, Matthew Mason, George Miles, Robin Mooring, Christa Sammons, E.C. Schroeder, Claire Schwartz, Sandra Stein, and Tim Young.

Finally, to Pat Willis and Robert Stepto, and all the other keepers of the flame.

Melissa Barton
Curator, Prose and Drama, Yale Collection of American Literature

CREDITS

All works shown in this book are the physical property of Beinecke Rare Book and Manuscript Library, Yale University. Grateful acknowledgement is made to the following for permission to publish these works.

Cover image by Aaron Douglas

"Gather out of star-dust": excerpt from "Dream Dust" from *The Collected Poems of Langston Hughes* by Langston Hughes, edited by Arnold Rampersad with David Roessel, Associate Editor, copyright © 1994 by the Estate of Langston Hughes. Used by permission of Alfred A. Knopf, an imprint of the Knopf Doubleday Publishing Group, a division of Penguin Random House LLC. All rights reserved.

"Go Harlem": excerpt from "Go Harlem," music by James P. Johnson, lyrics by Andy Razaf

Jean Toomer, notebook, © 2016 Yale University

Cover of *Crisis* © National Association for the Advancement of Colored People

Cover of Opportunity © National Urban League OPPORTUNITY: Journal of Negro Life

Langston Hughes, "The Negro Artist and the Racial Mountain," from The Nation, June 23, 1926 © 1926 The Nation. All rights reserved. Used by permission and protected by the Copyright Laws of the United States. The printing, copying, redistribution, or retransmission of this Content without express written permission is prohibited.

Edward Steichen, Portrait of Florence Mills © 2016 The Estate of Edward Steichen / Artists Rights Society (ARS), New York

E. Simms Campbell, *Night-Club Map of Harlem*, courtesy of Elizabeth Campbell-Moskowitz

Aaron Douglas, *Prodigal Son* and design for Carl Van Vechten's bathroom © Heirs of Aaron Douglas/ Licensed by VAGA, New York, NY

James Van Der Zee, *Couple* and *The Valentine Tea at Walker Shop #1*, © 2016 Donna Mussenden Van Der Zee

Miguel Covarrubias, drawing of W. C. Handy, © María Elena Rico Covarrubias

Stephen Longstreet, Harlem Sketchbook, © Estate of Stephen Longstreet

Alain Locke, letters to Langston Hughes, courtesy of Moorland Spingarn Research Center, Howard University

Countée Cullen, letter to Langston Hughes, copyright is held by Amistad Research Center, Tulane University, and administered by Thompson and Thompson, New York, NY, Amistad Research Center and Estate of Ida M. Cullen

Image of Claude McKay correspondence with Langston Hughes is used with the permission of the Literary Estate for the Works of Claude McKay

Carl Van Vechten, portraits of Zora Neale Hurston and list of materials donated to James Weldon Johnson Collection, © Van Vechten Trust

Winold Reiss, *The Brown Madonna*, courtesy of Renate Reiss

Sterling Brown, letter to James Weldon Johnson, © Sterling Brown Estate

Published by Beinecke Rare Book & Manuscript Library, P.O. Box 208330, New Haven, Connecticut 06520-0330 beinecke.library.yale.edu

Distributed by Yale University Press, P.O. Box 209040, New Haven, Connecticut, 06520-9040 www.yalebooks.com

Printed by GHP, West Haven, Connecticut

Design by Daphne Geismar

Photography by Meredith Miller

ISBN 978-0-300-22561-7

Library of Congress Control Number: 2016943615

This book is set in Gotham (display) and Gotham Narrow (text). Gotham, designed in 2000 by Tobias Frere-Jones, is a typeface based on sans serif lettering found on signs and publications throughout New York City between the two World Wars. The titles use letterforms created by Aaron Douglas and used on book jackets and magazine covers designed by Douglas during the Harlem Renaissance.